The Critical Idiom

General Editor: JOHN D. JUMP

29 *Expressionism*

In the same series

Expressionism/R. S. Furness

Methuen & Co Ltd

First published 1973
by Methuen & Co Ltd
11 New Fetter Lane London EC4
© 1973 R. S. Furness
Printed in Great Britain
by Cox & Wyman Ltd, Fakenham, Norfolk

ISBN 0 416 75660 3 Hardback
ISBN 0 416 75670 0 Paperback

Distributed in the U.S.A. by

HARPER & ROW PUBLISHERS, INC.
BARNES & NOBLE IMPORT DIVISION

Contents

General Editor's Preface

The volumes composing the Critical Idiom deal with a wide variety of key terms in our critical vocabulary. The purpose of the series differs from that served by the standard glossaries of literary terms. Many terms are adequately defined for the needs of students by the brief entries in these glossaries, and such terms do not call for attention in the present series. But there are other terms which cannot be made familiar by means of compact definitions. Students need to grow accustomed to them through simple and straightforward but reasonably full discussions. The purpose of this series is to provide such discussions.

Many critics have borrowed methods and criteria from currently influential bodies of knowledge or belief that have developed without particular reference to literature. In our own century, some of them have drawn on art-history, psychology, or sociology. Others, strong in a comprehensive faith, have looked at literature and literary criticism from a Marxist or a Christian or some other sharply defined point of view. The result has been the importation into literary criticism of terms from the vocabularies of these sciences and creeds. Discussions of such bodies of knowledge and belief in their bearing upon literature and literary criticism form a natural extension of the initial aim of the Critical Idiom.

Because of their diversity of subject-matter, the studies in the series vary considerably in structure. But all authors have tried to give as full illustrative quotation as possible, to make reference whenever appropriate to more than one literature, and to write in such a way as to guide readers towards the short bibliographies in which they have made suggestions for further reading.

John D. Jump

University of Manchester

I
Origins

PROBLEMS OF DEFINITION

'Expressionism' is a descriptive term which has to cover so many disparate cultural manifestations as to be virtually meaningless: of all the 'isms' in literature and art it seems the one most difficult to define, partly because it has a general, as well as a specific application, and partly because it overlaps to a great extent with what can be called 'modernism', as well as having antecedents in Baroque dynamism and Gothic distortion. The situation is summed up with admirable clarity by Malcolm Pasley, who writes in *Germany, A Companion to German Studies*: 'Whether we want to attach this label (i.e. expressionism) to a particular author or work depends on the importance we allow to the following: (i) the use of various anti-naturalistic or "abstracting" devices, such as syntactical compression or symbolic picture-sequences, (ii) the assault on the sacred cows of the Wilhelmine bourgeoisie from a left-wing internationalist position, (iii) the choice of the theme of spiritual regeneration or renewal and (iv) the adoption of a fervent declamatory tone.' (p. 579.) The first point refers to an international tendency in the arts, while the other three denote a more German pre-occupation and, unfortunately, the word 'expressionism' has to cover both these meanings.

What this present study will attempt to do is to describe both that which is called expressionism in general and also what is called German Expressionism; it will take as its starting point the cultural situation in Europe at the end of the nineteenth century to see how the movement known as expressionism arose, particularly

in lyric poetry, the theatre and the plastic arts. An analysis of what is called German Expressionism will then follow, and we shall look at the links between that particular tendency and the more general outlook prevailing elsewhere; finally we shall take stock of the situation after the waning of the German movement, to see what expressionistic features may have survived. The Germans were not the innovators, but the catalysts; although this study will focus upon Germany, the expressionistic precursors and developments elsewhere will be of equal importance.

PRECURSORS

The transition from the nineteenth to the twentieth century in Europe is characterized by a plethora of artistic styles and movements, a rich confusion with no clear-cut tendency or direction. The various 'isms' follow each other, or exist side by side, or overlap: naturalism, impressionism, symbolism, neo-romanticism, art-nouveau, then futurism and expressionism – these are the labels which, frequently unsatisfactorily, adhere to the conflicting ways of thought and feeling which crystallized between the late 1880s and the early 1920s, and which betray a profound uncertainty in man's imaginative response to the world around him.

A certain degree of over-simplification is perhaps inevitable during a discussion of literary movements and their aims. But a tendency which becomes increasingly apparent in these years is what might be called anti-naturalism. It would be false to see in symbolism a 'reaction' here, for the two schools, both stemming from France, exist side by side: neither is it correct to see impressionism as a movement away from naturalism, for the two schools have much in common; it would be closer to the truth to see, on the one hand, a naturalist-impressionist tendency and, on the other, a symbolist-neoromantic attitude in literature and the arts. The former movement would contain the names of the French

novelists such as Zola, Maupassant and the Goncourts, also the French painters who conveyed the tactile essence of reality on their canvasses and, in the theatre, the names of Ibsen and Gerhart Hauptmann; the latter movement would claim Mallarmé and Verlaine, Huysmans and Maeterlinck, Stefan George, early Rilke and Hofmannsthal. The naturalist-impressionist tendency found in life material which was worthy of description and comment; the symbolist-neoromantic attitude was one of flight from the world towards the creation of artificial paradises and rarefied beauty.

It became apparent, however, that both these attitudes failed to satisfy on a profound level. For naturalism and impressionism remained too near the surface of things, while symbolism and neoromanticism, in their flight towards the rarefied and the refined, became ultra-precious, decadent and jejune: a new vision, a new energy and a new restlessness were needed. It is not simply that a more 'modern' way of thinking and feeling was felt to be lacking, for the naturalists had prided themselves on their modernity, but art seemed to have reached an impasse: a new passion was needed, a new pathos, the expression of a subjective vision regardless of mimesis, a concern for human life, a concern for man crushed by pitiless machinery and ruthless cities which was far more intense and poignant than the naturalist's description of social conditions. Likewise the emphasis on inner vision, on the creative powers, on the imagination above all, was to exceed the symbolist cult of the soul. More vital emotions, more dynamic powers of description were extolled, a creation from within, an intense subjectivity which had no reluctance in destroying the conventional picture of reality in order that the expression be more powerful: this is the new tendency. And if distortion and aggressive expression of emotion were found in earlier works of art, then these works were extolled as forerunners of the new outlook.

Like so many titles used to designate the various literary movements, the term 'expressionism' originated in painting, and only

later came to describe a literary phenomenon. John Willett finds the terms used as early as 1850 to describe 'modern' painting; he also quotes it (in *Expressionism*, Weidenfeld and Nicolson, London, 1970, p. 25) as having been used in Manchester in 1880 to describe 'those who undertake to express special emotions or passions'. Many critics point to the use of the word 'expressionist' to designate the particular intensity of the work of those painters who strove to go beyond impressionism, beyond the passive registration of impressions towards a more violent, hectic, energetic creativity such as is found above all in Van Gogh. The dissolution of conventional form, the abstract use of colour, the primacy of powerful emotion – above all the turning away from mimesis herald a new consciousness and a new approach in painting, which literature was to follow. The growing independence of the image, the absolute metaphor, the intense subjectivity of the writer and the probing of extreme psychological states – above all the artist as creator, as passionate centre of a whirling vortex: all this becomes more and more apparent, as both the objectivity of the naturalists and the *l'art pour l'art* aspect of symbolism are left far behind.

A most interesting letter which demonstrates the reservations felt by Zola when confronted by the new direction in the theatre is that which he wrote to Strindberg on December 14th, 1887, to comment on the latter's play *The Father*. Zola objected to the schematic nature of Strindberg's characters, their lack of reality, and to the Captain particularly, 'who does not even have a name . . .'. Zola felt estranged from the new direction that Strindberg's drama was taking, a path towards abstraction, to the use of types rather than individuals and a lack of concern for naturalistic plausibility; here was no 'coin de la nature vu à travers un tempéra-ment' ('segment of nature seen through the eyes of a certain temperament'), but life flowing through a soul, a universalization of autobiographical material. *The Dance of Death* (1900) would,

surely, also have met with Zola's strictures, with its effect almost of pantomime, its two primitive creatures locked in a love-hate embrace using a contrapuntal dialogue on their claustrophobic island.

It is, however, not until *To Damascus* (1898–1901) that a work is encountered which definitely marks the end of naturalist drama for Strindberg; it has been called the first expressionist play, where all the characters are emanations of a soul, symbolizing powers with whom the Unknown One is in combat. The canons of naturalism, the demand for plausibility and inner logic are totally ignored: an intense subjectivity prevails. The beggar, the woman, the doctor and the madman Caesar all represent aspects of the Unknown One's psyche, and move before him during his journey of self-discovery. They can be called symbols: the beggar is that degradation which the arrogant protagonist fears, yet which is necessary for his rebirth; he is the embodiment of the Unknown One's repressed thoughts, a reminder of a possibility of existence towards which the hero must move. Walter Sokel, in *The Writer in Extremis* (Stanford, 1959, p. 35) calls him 'the literal embodiment of a leitmotiv, an aesthetic attribute in the disguise of a human shape, a function of the dramatic idea'. The woman would be the link with life, a fusion of the sexual and the sublime which torments and inspires; the Doctor represents the Unknown One's guilt, while Caesar the madman would be a caricature of the protagonist's arrogance and pride. The complex trilogy portrays a gradual process of self-awareness, a Road to Damascus both painful and necessary, a Passion marked by the stations of the cross. The Christian terminology used here is appropriate, for the concern with the soul, with the inner life and the birth of a new man, betray an undeniably religious concern which will characterize many expressionist writers: the ego is seen as a magic crystal in which the Absolute is in constant play.

It may be of interest here to mention briefly a remarkable piece

of dramatic writing which anticipates Strindberg's method by over three hundred years. This is Act Three of *King Lear*, in which, in scenes iv and vi, both the natural elements and the characters may be regarded as manifestations of Lear's tormented condition. The spectator enters into Lear's mind by seeing him grouped with three other characters, each of whom is a projection of some part of that mind. Through the Fool, Lear's repressed self-reproach rises to consciousness; Kent, as the loyal servant, recalls those supposedly 'natural' relationships of King and subject, master and servant, parent and child, which sustained Lear in the role that was his early in the play; Poor Tom (who is really Edgar, but for the time being Edgar is lost in Poor Tom) is Lear's vision of man deprived of those relationships and of all other removable supports, in short, 'unaccommodated man'. Lear's discovery of truths about himself and about the life around him is communicated to us through the movements, gestures and speeches of this group of characters.

With *A Dream Play* (1901–1902) Strindberg approached an almost neo-romantic mystery play such as Hofmannsthal might have written (with the description of the castle of life, for instance, from which the crysanthemum-soul arises), but that which might be called the expressionist element is seen in the way in which the characters appear as symbols or fragments of a dreaming mentality. In the 'Reminder' which Strindberg desired to have printed on the programme he wrote: 'The characters split, double, multiply, vanish, solidify, blur, clarify. But one consciousness reigns above them all – that of the dreamer; and before it there are no secrets, no incongruities, no scruples, no laws. There is neither judgement nor exoneration, but merely narration.' (See C. L. Dahlström, *Strindberg's Dramatic Expressionism*, Ann Arbor, 1930, p. 177.) The concentration on a dream-reality, of course, looks forward to surrealism, but it also exemplifies a growing tendency of expressionism to admit, and extol, the mystical, quasi-religious yearnings

of the human soul. It is obvious that Strindberg is of great importance in any inquiry into the roots of the anti-naturalist tendency in the theatre: between 1913 and 1915 there were one thousand and thirty-five performances of twenty-four different Strindberg plays in Germany alone, and it was in Germany above all, as we shall later see, that Strindberg's expressionist tendency was to be developed and modified.

If *To Damascus* portrays the soul's struggles to find and transcend itself, then a writer must be mentioned who is of crucial importance at this time, and who may well be seen caricatured as Caesar in Strindberg's play. This is Friedrich Nietzsche, with whom Strindberg corresponded briefly before and at the time of Nietzsche's mental collapse (Nietzsche's letter of 7 December 1888 congratulated Strindberg on his own translation into French of *The Father*, and suggested that Strindberg might undertake the translation of *Ecce Homo*). A discussion of Nietzsche is vital in any description of the precursors of expressionism: he is a European, rather than simply a German, phenomenon and, for good or for ill, stands behind so many developments in twentieth-century art and thought. The dithyrambic ecstasy of *Thus Spake Zarathustra* reverberated through literature and music before the First World War; a perverse distortion of his thinking also became apparent in the Third Reich. It was Nietzsche's emphasis on self-awareness, self-mastery and passionate self-fulfilment that gave the expressionist mode of thought its keenest impetus. The naturalists may have applauded Nietzsche's attack on bourgeois complacency, and the symbolists have thrilled to his vision of the poet-prophet remote in azure loneliness: it was the expressionist generation, however, which was overwhelmed by his daring pathos, his insistence on the destruction of the old and moribund, and his emphasis upon daring and vision. 'Develop each of your powers – but this means: develop anarchy! Perish!' 'Where is the lightning to lick you with its tongue? Where is the madness with which you

should be filled?' 'My brothers, destroy, destroy the ancient tablets!' Nietzsche's imperious apostacy thrilled a whole generation of poets and thinkers; his emphasis upon idealism, upon the will and upon passionate ecstasy found its counterpart in the intense subjectivity of many of the expressionists, and their demand for a New Man, whose features often bore a distinct resemblance to those of Zarathustra. Above all it was Nietzsche's worship of creativity and the life-force which struck the deepest roots in the new mentality.

But the movement, or mentality, known as expressionism is complex, and contains many divergent tendencies and contradictions which are to be found at the heart of Nietzsche himself. Beneath the passionate proclamations and the dithyrambic ecstasies a softer tone is heard in Nietzsche, a voice full of disquiet and foreboding. The madman who appears on the market-place (see Book Three of *The Gay Science*) flings his lantern to the ground and cannot hold back his fearful knowledge that, after God's death, man is plunging into icy nihilism. 'Where are we moving? Away from all suns? Are we not staggering, backwards, forwards, sideways, in all directions? Is there an Above, a Below? Are we not wandering through an eternal nothingness? Does not empty space breathe at us? Has it not grown colder? . . .' Can man indeed fill the void of God's absence, or is man not destroyed by the enormity of the crime of deicide? Is man striding forward to a new vision, glorious in his beauty and power, or is the world moving into anarchy and disintegration? Nietzsche's own uncertainty was reflected in the different emphases of the expressionist writers, some of whom glory in spiritual and political visions of Utopia while others are unable to banish the spectre of nihilism and anticipations of a universal dread. The tensions in expressionism, particularly in Germany, do not simply result from the hopes and terrors brought about by the First World War: they go back to Nietzsche, but are also, of course, the positive and negative

poles of the human psyche; the expressionist writers, however, with their predilection for extreme states of tension, ecstatic or desperate, seem more prone to hyperbole. The cry or shriek, so often met with in expressionist art, need not necessarily be one of joy: Edvard Munch showed in his famous lithograph of 1894 that it may also be a scream of existential terror.

The soul under stress, racked and burning in fearful incandescence – this preoccupation may be called expressionist. It brings Nietzsche very much to mind, also Dostoevsky, the only psychologist, Nietzsche explained, from whom he had anything to learn. As in the case of Strindberg, Nietzsche came to Dostoevsky late in his creative life, but immediately sensed that here was a writer whose psychological finesse and fearless probing of the darker corners of the psyche were to be admired. It is interesting to observe the fascination that Dostoevsky held for a great many writers, particularly in Germany, between 1900 and 1925. The naturalists had praised him as a 'realist' because of his descriptions of poverty and social outcasts: *Crime and Punishment* was the great impetus here. But later the emphasis shifted to Dostoevsky as an explorer of pathological conditions, as the psychologist of crime, and in the expressionist period it was the irrational and the pseudo-religious aspects of the writer which came to the fore. The dominating influence in the Dostoevsky cult in Germany was above all Moeller van den Bruck who edited, with Dmitri Mereschkowski and others, the great Piper edition of Dostoevsky's work, commenced in 1906. Moeller van den Bruck wrote prefaces to several of the volumes in this edition, and propagated his own views on art and society through the mouthpiece of the Russian novelist: between 1908 and 1923 Piper Verlag printed 65,000 copies of *The Brothers Karamazov*; in the twenty years between 1914 and 1934 the *Legend of the Grand Inquisitor* reached 110,000 copies in the Insel edition alone. But the peak of the cult coincided with the climax of German Expressionism: between 1920 and 1922

there were nearly half a million copies of the works of Dostoevsky published and translated in the Piper edition: Dostoevsky's reactionary mysticism, his anti-Westernism and fervent patriotism undoubtedly inspired Moeller van den Bruck's own work *Das dritte Reich*. It is false to equate the expressionist mentality with radical left-wing attitudes; although many of the German Expressionists, particularly during the First World War, did join the socialist and communist parties, the burning idealism unleashed could and frequently did express itself in right-wing politics. The emphasis on the subjective, the flirtation with the irrational, the desire for a New Man did find an outlet, as we shall see, in National Socialism, and Dostoevsky's idea of the 'conservative revolution' also appealed directly to a writer like Thomas Mann, who acknowledges this in his *Meditations of a Non-Political Man*; it is interesting, however, that the left-wingers Kurt Eisner and Rosa Luxemburg should have found his influence pernicious.

Dostoevsky's contribution to the expressionist mentality is considerable. He shares with Nietzsche and Strindberg an emphasis on extreme, often pathological psychological states, on the rejection of 'normal' canons of thinking and feeling, on the need for a daring transvaluation of values. Both Nietzsche and Dostoevsky stress the need for a spiritual revival, a New Man born of suffering and passion. As Zarathustra destroyed the tablets of the law, so Dostoevsky seemed to stand beyond good and evil, a frightening, and yet liberating visionary: the fervent, even febrile quality of his writing was worshipped by a generation grown tired of naturalistic dullness and neoromantic velleities.

In Russia, Sweden and Germany, and also in America, the precursors of the expressionist mentality are to be found. A most potent force was the poetry of Walt Whitman, who has much in common with Nietzsche, and whose vitalism later found an undeniable echo in expressionist rhapsodic utopianism. The

following lines from *The Mystic Trumpeter* could well be taken
from the German Expressionist Franz Werfel:

> A reborn race appears – a perfect world, all joy!
> Women and men in wisdom innocence and health – all joy!
> Riotous laughing bacchanals filled with joy!
> War, sorrow, suffering gone – the rank earth purged – nothing
> but joy left!
> The ocean filled with joy – the atmosphere all joy!
> Joy! joy! in freedom, worship, love! joy in the ecstasy of life!
> Enough to merely be! enough to breathe!
> Joy! joy! all over joy!

And Dostoevsky's *From the House of the Dead* seems very
close in spirit to the sentiment expressed in the lines from *You
Felons on Trial in Courts*:

> Lust and wickedness are acceptable to me,
> I walk with delinquents with passionate love,
> I feel I am of them – I belong to those convicts and
> prostitutes myself,
> And henceforth I will not deny them – for how can I deny myself?

It is Zarathustra who is adumbrated in the following lines:

> Dazzling and tremendous how quick the sunrise would kill me,
> If I could not now and always send sun-rise out of me …
> <div align="right">(Song of Myself)</div>

and Nietzsche himself here:

> Do I contradict myself?
> Very well then I contradict myself,
> (I am large, I contain multitudes.)
> <div align="right">(Song of Myself)</div>

And Whitman, addressing the creative potential of the New
World, strikingly anticipates the emphasis on the modern which
will also play a considerable role in the expressionist outlook:

B

Brain of the New World, what a task is thine,
To formulate the Modern – out of the peerless grandeur of the
 modern,
Out of thyself, comprising science, to recast poems, churches, art
(Recast, maybe discard them, end them – maybe their work is
 done, who knows?)
By vision, hand, conception, on the background of the mighty
 past, the dead,
To limn with absolute faith the mighty living present.
 (*Thou Mother with thy Equal Brood*)

Here an Italian, Filippo Marinetti, must be mentioned, author
of the *Futurist Manifesto* (1909), which extolled in rhapsodic
admiration the age of the machine. 'We shall sing of great crowds
in the excitement of Labour, Pleasure or Rebellion; of the nocturnal
vibration of arsenals and work-shops beneath their electric moons;
of greedy stations swallowing smoking snakes; of adventurous
liners scenting the horizon; of broadchested locomotives galloping
on rails . . .'. The most famous statement of Marinetti, however,
is the following: 'We maintain that the splendour of the world
has been enriched by a new beauty: the beauty of speed. A racing-
car decorated with exhaust-pipes like snakes spitting fire, a
menacing racing-car which roars into the distance like a burst of
machine-gun fire is more beautiful than the Winged Victory of
Samothrace . . .' (see the introduction to *The Penguin Book of
French Verse*, ed. Anthony Hartley, p. xxxix, also the article on
'Expressionismus und Technik' in *Expressionismus als Literatur*,
ed. Rothe, 1969, p. 173). His novel *Mafarka le Futuriste* (1909)
depicts a mechanical superman who flies and eventually conquers
space; his novels were translated into German and his lecture in
Berlin in 1913 had a profound effect. Marinetti and the group
associated with him were bent upon the destruction of symbolism:
the desire to 'murder the moonlight' was an attempt to rid
literature of the subtleties and exquisite shadings of the symbolist
school. Futurist art was above all an attempted identification with

modern life, with speed and the machine, and in their movement away from the embodiment to the idea they anticipated the idea of conceptual art. Wyndham Lewis, as we shall later see, came to terms with Marinetti and futurism in the first number of *Blast*.

There seems to be a paradox here: how can the praise of the aggressively technological be reconciled with the desire to preserve human imagination and creative expression? Does not the machine stunt and maim? Later it will be Georg Kaiser and Ernst Toller in Germany, also Eugene O'Neill and Elmer Rice in America, who portray the juggernaut in all its ferocity. But the machine could also be extolled as an expression of the human will, of human power and inventiveness: the futurist-expressionist looked upon man as the modern Prometheus, the machine (train, aeroplane or motor-car) as guarantor of freedom and escape. As a manifestation of man's creative vision the machine was worthy of praise: as an exemplification of modernity it was accepted by all those who longed to cast aside tradition and set forth into the unknown. Whitman himself had had his vision, the 'new race dominating previous ones, and greater far, with new contests,/ New politics, new literatures and religions, new inventions and arts' (*Starting from Paumanok*); he summed up so well the need to affirm all, man and machine, in a fervent pantheistic embrace:

> As for me, (torn, stormy, amid these vehement days,)
> I have the idea of all, and am all and believe in all,
> I believe materialism is true and spiritualism is true, I reject no
> part . . .

> *(With Antecedents)*

To conclude: the movement, or tendency, or mentality known as expressionism emerged in Europe from an intellectual climate consisting of diverse features, amongst which Nietzsche's vitalism, Marinetti's futurism, Whitman's pantheism and Dostoevsky's psychological probing into sub-rational darkness play an important part. A further impetus came from Bergson, whose

description, in *Essai sur les données immédiates de la conscience* (1889) of 'le moi d'en bas qui remonte à la surface' ('the subterranean ego which rises to the surface') and 'la croûte extérieure qui éclate, cédant à une irrésistible poussée' ('the outer crust which bursts, giving way to an irresistible force') is a further emphasis on subjective force and radical change. Everywhere the call is for self-expression, creativity, ecstatic fervour and a ruthless denial of tradition: the arts are ready for a new beginning, a new departure or *Aufbruch*, and expressionism, in its vitalism and forcefulness, seems a fitting herald for the new century.

2

Formal Innovations: expressionism and modernity

Whether it was Paul Cassirer, the art-dealer, in the presence of a selection committee looking at a painting by Max Pechstein, or the *Figaro* critic Louis Vauxcelles, or Wilhelm Worringer, the art historian, in his work *Abstraktion und Einfühlung* who first brought the term 'expressionism' into common usage is unknown and ultimately unimportant: what is of interest is that it was the world of painting, as was mentioned in the first section, which first demonstrated the new expressive force, the anti-mimetic tendency, the movement towards abstraction. In France it was the cubists and the fauves who reacted against impressionism; the famous Salon d'Automne exhibition of *fauvisme* in 1905 brought a new and disturbing world before the public gaze. In Germany the modern, expressionist painters formed two schools, firstly *Die Brücke* in Dresden in 1905 (amongst them Heckel, and Schmidt-Rottluff), and then *Der blaue Reiter* in Munich in 1912, including such famous names as Franz Marc, August Macke and, above all, Kandinsky. It is enlightening to look briefly at the art world to see the tendencies which will become apparent likewise within the new poetry: this is also permissible as many of the expressionists, rather like the German romantics a century before, had stressed the ultimate union of all the arts and, perhaps with more success, had demonstrated this in their achievements: Schoenberg was both musician and painter (his remarkable pictures, when exhibited in Vienna in 1910, created much the same *succès de scandale* as the 'Five Orchestral Pieces'); Kokoschka

was painter and playwright, Ernst Barlach drew and sculpted and wrote plays of outstanding quality, and Kandinsky was a lyric poet and a dramatist as well as being an important innovator in painting.

An expressionist canvas makes an almost physical attack on the observer, and it was Van Gogh with his violent brushwork and unrealistic colours who was one of the first to concentrate on the expression of disturbing and emotional experiences, conveying, in *L'Arlésienne*, with red and yellow the frightening passions of man. In Van Gogh it becomes more and more apparent that colour attains increasing independence as a carrying force of emotion; it arouses a response without the help of conventional form. This abstracting of colour from traditional composition is also seen in expressionist poetry, particularly in the work of the Austrian poet Georg Trakl (1887–1914): the problem concerning the abstracted or 'autotelic' (or independent) image is of interest here, the image not as a projection of reality but an inner truth told in line and colour, or in a manipulation of words. An important work in this context is Kandinsky's *Über das Geistige in der Kunst* (*Concerning the Spiritual in Art*) (1912), which, quickly translated, reached a wide audience in many countries. Art, for Kandinsky, was neither decoration, nor entertainment, nor a mere mirror of nature: each work of art was to be the manifestation of a creative vision, and each colour was to transmit an emotional state. Of the artist Kandinsky wrote: 'Sein offenes Auge soll auf sein inneres Leben gerichtet werden und sein Ohr soll dem Munde der inneren Notwendigkeit stets zugewendet sein . . . (p. 84). Der Künstler ist nicht nur berechtigt, sondern verpflichtet, mit den Formen so umzugehen wie es für seine Zwecke notwendig ist' (p. 133). ('His open eye should be fixed upon his inner life, and his ear should always be turned to the mouth of his inner necessity . . . The artist is not only justified in treating form in any way that is necessary for his purpose, but is obliged

to do this.') An extreme subjectivity is underlined here, with the artist as creator, driven by an inner necessity. 'Das ist schön, was einer inneren seelischen Notwendigkeit entspringt. Das ist schön, was innerlich schön ist' (p. 137). ('Beautiful is that which springs from an inner necessity; beautiful is that which is inwardly beautiful.') (The quotations are taken from the 8th edition, Berne, Benteli, 1965.) Kandinsky also stressed a mingling of the senses and of the art-forms, a visual mysticism in the manner of Rudolf Steiner and a synaesthesia which recalls Rimbaud and Scriabin; this is seen in his experimental stage works *Der gelbe Klang* of 1909 and *Violett* in 1911, also in the abstract woodcuts *Klänge*.

Abstraction of colour, inner necessity, the artist as sole legislator and creator of a new reality – these ideas become translated more and more into writing, particularly poetry. Walter Sokel has described very clearly the philosophical foundation of modernism to be found in Kant, who shattered the formulation of art as mimesis by insisting that nature does not exist outside the mind, and hence the imitation of nature would become a somewhat dubious affair. Sokel discusses Kant's concept of the 'aesthetic idea' and his recognition of the metaphor as an 'aesthetic attribute' of language which reveals a reality surpassing the logical: this is linked to Mallarmé's 'la parole essentielle', an aesthetic phenomenon used to produce emotional effects and symbolic worlds. He also describes the use of emotional, aesthetic attributes, or symbols, in nineteenth-century realism, for example, in Flaubert, where, in *Madame Bovary*, the blind, deformed beggar, although enjoying a fair degree of plausibility, of 'reality', also becomes a symbol, or 'metaphor', being a demonstration of the heroine's inner condition, and a foreshadowing of what is to come. Flaubert here expresses the main character's repressed, even unknown, feelings by embodying them in another character, this symbolic character becoming an objective correlative for

certain inner states. This tendency became important in Strind-
berg, as was seen, and will be seen in the plays of German Expres-
sionism; it will be found in the Nighttown section of Joyce's
Ulysses and also in Kafka, where metaphor is treated as actual
fact (in *Die Verwandlung*): instead of quality becoming attached
to a substantive, substance becomes a function of quality. As
Kandinsky created pure compositions of colour and line, so many
expressionist poets created pure composition of autonomous
metaphors which stand as abstracted and powerful nuclei of
feeling.

The problem of the metaphor is central to expressionism. It
seems a characteristic of poetry since, roughly speaking, the
beginning of the century, that the metaphor has become more
complex in that the link or point of comparison between the two
worlds has become less evident, more personal, laconic or esoteric.
Ezra Pound's lines, 'In a station of the Metro', are a useful
example: 'The apparition of these faces in the crowd:/Petals, on
a wet, black bough', where the appearance of wet petals against
the darkness suggests faces glimpsed in the Underground, the
condition belonging to both worlds being, probably, hopelessness
and vulnerability. T. S. Eliot's 'The yellow fog that rubs its
back upon the window panes' (in *Prufrock*) is a most effective
picture: the dirty fog partakes of the furtiveness and stealth of
a tomcat. But it is obvious that a gradual dissociation of the two
realms (the situation and the referent) is undeniable: in Pound's
case the link petals/faces is still acceptable, whereas in Eliot's
case fog/cat is more tenuous. And the tendency for the metaphor
to become more and more independent and increasingly 'absolute'
is one of the hallmarks of modern poetry. The absolute metaphor
would be one in which the original situation, the experience
which should call to mind the comparison, no longer appears.
A concrete situation fades behind a weight of metaphorical
associations: it is as though a noun were lost behind its attributive

adjectives (a situation prevalent in the poetry of the Austrian Georg Trakl). An extreme subjectivity would result here, where the poet's metaphors (or epithets) replace the actual existing situation or object; the metaphor would then exist in its own right *as an image*, often juxtaposed with other images to create a world remote from the real. The metaphor (or image) becomes *expressive* rather than imitative, existing as a powerful, autonomous figure of speech from which radiate a host of evocative meanings. An example often quoted here is the last line of Guillaume Apollinaire's 'Zone' (from the collection *Alcools*): 'Adieu adieu/Soleil cou coupé', where the link between sun and cut throat is indeed tenuous, and it is for the reader to grasp the point of comparison – the idea of termination, finality, sunset, redness and blood.

An absolute or autotelic metaphor may also be called an image, an image being defined as a simile, metaphor or figure of speech, an objectification or re-enactment of an inner experience. It may also be said that, in modern poetry, images become autotelic in the sense that they become increasingly divorced from the object and exist as evocative forces. It was Ezra Pound again who attempted to define the image as he saw it in modern poetry: 'An "image" is that which presents an intellectual and emotional complex in an instant of time' (*Poetry*, March 1913), and again: 'The image is not an idea. It is a radiant node or cluster; it is . . . a VORTEX, from which, and through which, and into which, ideas are constantly rushing' (*Gaudier-Brzeska. A Memoir*, p. 106). An imagist would be he who seeks clarity of expression through the use of precise images, but 'precise' not in any naturalist or impressionist sense, but rather meaning effective, disturbing (possibly shocking) and expressive. Imagist poets, writes Michael Hamburger, 'deal with bare phenomena in the form of images, not as an ornament added to what they have to say, nor as a means of illustrating a metaphysical statement, but as an end in itself. The mere existence of phenomena is their justification: and

to understand their Being is to understand their significance. The poetic image, then, becomes autonomous and "autotelic", or as nearly so as the medium of words permits . . .' (*Reason and Energy*, London, 1957, pp. 239–40).

The links between what might be called imagism and expressionism are very close. It is the condensation of juxtaposed images that characterizes the new poetry, particularly in Germany, where the names of Georg Trakl (1887–1914), Georg Heym (1887–1912) and Ernst Stadler (1883–1914) spring to mind. An impressionist poet would feel fascinated by the tactile, sensuous aspects of phenomena, whereas the expressionist (sharing much in common with the symbolist here) feels the need to point beyond, or to indicate by the sensitive use of images and symbols that the ultimate meaning of the world might lie beyond its purely external appearance. What is puzzling in much twentieth-century poetry is the fact that the same image might be used for different purposes, sometimes descriptive, sometimes symbolic; a symbolic extension of an image may sometimes be assumed.

For our present purposes it can safely be argued that the predominance of the image, with frequent symbolic overtones, *is* a characteristic of expressionism; the expressionist poet feels the need to use an image not merely as a mirror of external reality but as a crucial centre of meaning (Pound's vortex); it becomes independent, and is used to set up a host of echoes within the reader, to act as an impulse to his imagination or as a catalyst to his reactions. A skilful manipulation of images may not necessarily describe reality, but weave an incantatory spell which should induce the reader to discover for himself what the poet has experienced and wishes to express. Both image and symbol express an inner world of meaning, and are abstracted from common experience: image-as-metaphor and image-as-symbol move beyond mimesis, accumulate heightened meanings in a re-interpretation of the world. 'An "image" may be invoked once

as a metaphor, but if it persistently recurs, both as presentation and representation, it becomes a symbol, may even become part of a symbolic (or mythic) system' (Wellek and Warren, *Theory of Literature*, London, 1949, p. 193).

To sum up the argument so far: the outlook known as expressionism combines the following: a movement towards abstraction, towards autonomous colour and metaphor, away from plausibility and imitation; a fervent desire to express and create regardless of formal canons; a concern for the typical and essential rather than the purely personal and individual; a predilection for ecstasy and despair and hence a tendency towards the inflated and the grotesque; a mystical, even religious element with frequent apocalyptic overtones; an urgent sense of the here and now, the city and the machine seen not from any naturalistic point of view but *sub specie aeternitatis*; a desire for revolt against tradition and a longing for the new and the strange. The revolutionary fervour will later assume positive political direction, towards either communism or fascism (National Socialism). Expressionism will have much of the Baroque in it (its dynamic sweep and restlessness, also its *memento mori*) yet more of the Gothic (the distortion, abstraction and mystical ecstasy); artists of earlier centuries who had deliberately used distortion to obtain a greater degree of expressiveness were hailed as forerunners. In expressionism there is an undeniable tendency away from the natural, the plausible and the normal towards the primitive, the abstract, the passionate and the shrill; it is in the theatre and in the lyric that the tendencies are most marked, rather than in the novel, which remained closer to its nineteenth-century models. In its restlessness and its tendency towards the extreme the expressionist movement seems quintessentially German, rather than simply modernist, and it is therefore at German Expressionism that we shall now look.

3
The German Situation
1900-1914

In Germany the decade immediately preceding the outbreak of
the First World War is more memorable for the intensity and
vehemence of the critics than for the convictions of the defenders
of the existing order: every artist of note took up arms against
the stifling pomposity of Wilhelmine institutions, the complacency
and hypocrisy of bourgeois *moeurs* and the arrogance of a mili-
taristic caste. The attitude of revolt in Germany was more extreme
than in any other European country because of the more pro-
nounced philistinism of the established society and the traditional
feeling of isolation and vulnerability of the artist in Germany;
the theatre, particularly, anticipated by fifty years anything that
the British stage dared or deigned to consider. What the German
Expressionist playwrights portrayed with passionate earnestness
shortly before and after the war was already there, albeit in an
ironic and often cynical vein, in the plays of Frank Wedekind
(1864–1918).

To extol the power of sex and to attack a hypocritical, stultifying
society – these were Wedekind's main aims. He seems to derive
much from Nietzsche and Strindberg (whose second wife became
his mistress), also from the cabaret tradition: he performed on his
guitar in the Munich cabaret 'Die elf Scharfrichter', collaborated
on the satirical journal *Simplizissimus* and served a spell of im-
prisonment at the very beginning of the new century for *lèse-
majesté*. His first play, *Frühlings Erwachen (Spring Awakening)*
was begun in 1890 and received its first public performance in

1906: the attack on bourgeois morality is ruthless, and the school atmosphere particularly is singled out for bitter criticism. Yet here is no naturalist drama à la Hauptmann: a grotesque element is undeniable in the use of caricature, and the last scene, in a churchyard, completely abandons any attempt at realism. As the hero stands by the dead girl's grave (the stated cause of death being 'anaemia', the actual cause an attempted abortion) he is tempted by the headless ghost of a school friend (who had committed suicide after failing his examinations) to kill himself; as he is about to yield a 'masked gentleman' in evening dress (frequently played by Wedekind himself) steps from behind the tombs and persuades him to chose life instead. But there is no rhetoric or bombast: the representative of 'life' – Wedekind – seems a cynical *roué* and by no means a devout advocate of the virtues of living. Yet the farce of the staffroom scenes (the absurd names, the interminable wrangling about whether or not to open the window) and the grotesque ending do conceal a serious purpose: to praise the life-force and healthy sexuality as opposed to deceit, complacency and dull respectability.

The desire to shock is seen even more clearly in his two most famous plays, *Erdgeist* (*Earth Spirit*) and *Die Büchse der Pandora* (*Pandora's Box*), dating from the period 1895–1904. The Lulu-figure is both fascinating and revolting, a personification of woman which both Strindberg and Nietzsche would have endorsed, tempting, cunning, cruel and destructive. Does Wedekind glorify sex in these plays, is it a salvation from the drabness of life? Do we admire Lulu for her courage and ultimate integrity? Or is the story a moral one, showing how Lulu sinks to a sordid and fearful end – a victim of Jack the Ripper? Wedekind proclaims that he will show us 'das wahre Tier, das wilde, schöne Tier' ('the true animal, the wild, beautiful animal') in an almost Nietzschean way, but also prevents too close an involvement with the issues by the circus technique, the deliberate theatricality of the

whole thing, and the element of farce and absurdity. The alienation techniques look forward to Brecht, a great admirer of Wedekind, and it is Wedekind who shares with later German Expressionist writers the aggressive attack on Wilhelmine society (in the novel it would be Heinrich Mann who comes to mind), the praising of life and energy, the use of distortion and caricature and the overt rejection of naturalism (see the circus-master's contemptuous rejection of various Hauptmann 'heroes' in the prologue to *Erdgeist*). But Wedekind ultimately defies classification: his cynicism, self-travesty and satirical moralizing are far removed from the extravagant hyperbole of many German Expressionist playwrights.

The attack against red plush, potted plants and *bric-à-brac* is heightened and sharpened to ruthless precision in the plays of Carl Sternheim (1878–1942), whose comedies, entitled *Aus dem bürgerlichen Heldenleben (From the Heroic Life of the Middle-class)*, earned him the name of the modern Molière. If Wedekind is the cynical moralist, Sternheim is satirist pure and simple, aloof yet dedicated to a merciless attack; that which he shares with Wedekind is the anti-naturalist tendency, seen in the frequency with which Sternheim reduces his characters to types, and the deliberate artificiality of the language. He strove to break through the 'genteel' in the German language, to cut away sentimentality and platitudes: the foreshortening of language and syntax is highly self-conscious and very effective. This 'telegraphic' style could be an anticipation of the 'Neue Sachlichkeit' tendency of the later twenties, but can also be called expressionistic as it tends towards concentration, abstraction and extreme intensity. The synthetic curtness will appear very much to the fore in the plays of Georg Kaiser: in Sternheim it does not have the steely quality of Kaiser, but rather the deliberate quirkiness and unreality which alienates and yet fascinates the reader.

The deliberate flouting of Wilhelmine tabus is seen in the very

title of the play *Die Hose* (*Knickers*) of 1911, where the attractive wife of a small clerk loses this garment in the street just as the Emperor passes by; the husband, Theobald Maske, exploits this incident and uses his wife as bait to lure in lodgers. Maske verges on the grotesque throughout, yet it is difficult to know if he is simply a monster of selfishness or a man to be admired: the pusillanimous and prurient lodgers cut very sorry figures indeed beside him. In the next play, *Der Snob* (1914) Sternheim traces the fortunes of Maske's son Christian, and its successor, *1913* (1915), is the most expressionistic of the three in that it portrays a world ripe for destruction, where Maske's grandchildren, effete, brutal and opportunist, blindly pursue their aims on the very edge of the abyss. 'Nach uns Zusammenbruch! Wir sind reif!' ('After us the deluge! We're ripe for it!') calls Christian, and the play ends with the lights extinguished, and the wind blowing the curtains into the room. The play is dedicated to the memory of Ernst Stadler, one of the most talented of the early German Expressionist poets, who was killed in France early in September 1914. Albeit ironic, the idea of the need for a New Man seems also present in Sternheim here, and the tentative hope is expressed that something better might emerge from the holocaust. And although both Wedekind and Sternheim stand apart from many of the new tendencies in the theatre at this time, they nevertheless make their contribution to the new outlook.

The truly revolutionary features of the theatre are seen in a number of plays written by Kokoschka between 1907 and 1918, which incensed the theatre-going public on their appearance. As was pointed out in Chapter 2, the arts were closer together during expressionism than they had been in any other preceding movement in the nineteenth century, and although Kokoschka's plays do not possess the same important proportions in his output as those of Barlach do in his, they are nevertheless organically related to his painting and graphic work of the period and, both

as regards content and technique, they foreshadow some typical aspects of German Expressionist drama.

Kokoschka's first literary work was a lyrical monologue *Die träumenden Knaben* (*The Dreaming Boys*); dedicated to Gustav Klimt it is an erotic, *fin-de-siècle* reverie, a German *L'Après-midi d'un faune* with moments of original poetic invention. It could be called a typical piece of *Wiener Sezession*, but with his first play, *Mörder Hoffnung der Frauen* (*Murderer, the Hope of Women*), Kokoschka turns to the sombre and the violent in his treatment of the theme of the gulf between the sexes. It was written in 1907, a year after the important Van Gogh exhibition in Vienna and a performance there of Strindberg's *Dance of Death*.

In *Mörder Hoffnung der Frauen* (see *Die deutsche Literatur VII*, ed. Killy, Munich, Beck, 1967, pp. 661–4) the presentation of the fight between the sexes is febrile and nightmarish in its intensity. Like *Der brennende Dornbusch* (*The Burning Bush*) of 1911 it is simply a sequence of highly charged utterances, outbursts from the subconscious of the two antagonists, Man and Woman, which vary between attraction and repulsion. There can be no talk of plot here; it is a psychodrama, predominantly irrational, full of surging and ebbing emotions. The utterances are elliptical: lighting and lengthy stage directions emphasize the symbolic atmosphere of the whole. Heinrich von Kleist's *Penthesilea* seems to have provided the impetus here, with its murderous combat between hero and heroine: Nietzsche and Freud are also brought to mind. The Man and his followers are 'Bestürmer verschlossener Festungen' ('Besiegers of sealed fortresses'), whilst the Woman exults: 'Mit meinem Atem erflackert die blonde Scheibe der Sonne' ('At my breath the blond disc of the sun flares up'). There is both tenderness and brutality, but the sexual images of futile, senseless 'whirling' predominate, as the Man chants: 'Sinnlose Begehr von Grauen zu Grauen, unstillbares Kreisen im Leeren.

Gebären ohne Geburt, Sonnensturz, wankender Raum . . .'
('Senseless desire, from horror to horror, insatiable whirling in
emptiness, baring, but no birth, sun-plunge, staggering space . . .').
And the woman's followers proclaim: 'Der Streit ist unverständ-
lich und dauert eine Ewigkeit' ('The battle is incomprehensible,
and lasts an eternity'); finally the woman recoils, fearing that the
Man will dominate. In a furious outburst the Man kills the Woman,
and flees. Is the man an inadequate partner? Can he only assert
himself in a fit of gratuitous violence? There are echoes of the
Lulu tragedy here, also anticipations of Schoenberg's *Die glück-
liche Hand* (*The Fortunate Hand*), a short opera with a similar
theme, complex use of lighting and colour and the idea again of
the impossibility of true communion between man and woman,
the man being too cerebral, the woman too natural. But the
Kokoschka play (transposed into an opera in 1920 by Hindemith)
cannot be given a satisfactory interpretation: it is a violent eruption
which overwhelms, appals and amazes.

An amusing contrast is *Sphinx und Strohmann*, written in the
same year and described as a *curiosum*. It anticipates, if anything,
the Dadaist antics of the war years and was, in fact, staged by
them in 1917; it transposes into the absurd the fears of Strindberg's
Captain in *The Dance of Death*. Herr Firdusi's large straw head
is turned so that he cannot see his wife Anima, a sensual, Lulu-
like woman, who is fascinated by Herr Kautschukmann, an evil
scientist; as Herr Kautschukmann desires Anima he explains that
fear of a wife's adultery brings about death, and Herr Firdusi
dies, horns sprouting from his head. Nonsensical aphorisms are
shouted by an actor who sticks his head from the backdrop as
Herr Kautschukmann and Anima exult; in the 1917 performance
in Zurich Hugo Ball played Firdusi and Emmy Hennings Anima,
while Tristan Tzara played the parrot and provided the thunder
effects with reckless abandon.

It is interesting that when Kokoschka chose to illustrate Bach's

c

cantata no. 60, *O Ewigkeit, du Donnerwort* he saw the basic situation of the work (the long, troubled dialogue between Fear and Hope) in the same sombre terms as in his dramas; there is no harmony for him as there was in Bach. The gulf is still evident in the famous painting *Die Windsbraut* of 1914; there is the whirling turmoil, the man and woman who lie close, yet who are separated by immeasurable distances, the woman serene, the man tense, preoccupied and remote. The Austrian poet Georg Trakl saw this canvas; although he resorted to the mystical notion of androgyny in certain of his poems there is no such solution in Kokoschka.

The sex problem, then, looms large in the works of artists who may be described as early expressionists: a more important theme, however, is the relationship between father and son. The German playwrights, between 1900 and the war years, portrayed with incredible intensity and violence the clash between generations, in which incest and murder play an important part. This seems a common German theme in literature: the antecedents may be found in the *Sturm und Drang*, in early Schiller particularly. The father-figure becomes a symbol for authority, and the rebellion against this image reaches feverish and strident proportions. Reinhard Sorge prepared the way with his play *Der Bettler* (*The Beggar*) written in 1912, although not performed until five years later. The protagonist is a poet, an incarnation of pure feeling, who pioneers a new drama which will sweep away outmoded conventions, and bring spiritual illumination to the masses: he describes his vision thus:

> Das Werk! das Werk! und nur das Werk war Herr!
> Wie soll ich reden ... Ich will Ihnen Bilder
> Der Zukünfte erzählen, die in mir
> Mit Pracht sich aufgerichtet haben ...
> Hören Sie doch: es wird
> Das Herz der Kunst: aus allen Ländern strömen

Die Menschen alle an die heilende Stätte
Zur Heiligung, nicht nur ein kleines Häuflein
Erlesener! . . . Massen der Arbeiter
Schwemmt an die Ahnung ihres höheren Lebens
In großen Wogen . . .

(The work! the work! only the work was master! How shall I speak
. . . I will show you visions of future times, which splendidly have
risen within me. Listen! My work shall be the very heart of art:
from all the lands there stream men, men towards the holy place to
be redeemed – not just a little group of chosen ones! Masses of
workers feel in waves, tumultuous, a vision now of higher life. . . .)

The poet strides through various stations and experiences, in-
cluding the murder of his parents, to a realization, ecstatic and
yet desperate, of the meaning of his life, of his love and his
mission:

Laß sinnen . . . sinnen . . . Symbole . . . (Jäh empor, mit Händen
 aufwärts): O Trost des
Blitzes . . . Erleuchtung . . . Schmerztrost des Blitzes . . .
Symbole der Ewigkeit . . .
Ende! Ende! Ziel und Ende! . . .
Durch Symbole der Ewigkeit zu reden . . .
(Let me think . . . think . . . (Leaps up, his hands outstretched):
 Oh consolation of
Lightning . . . Illumination . . . Pain-consolation of lightning . . .
Symbols of eternity . . .
The end! the end! The goal and the end!
To speak through symbols of eternity . . .)

He struggles towards self-knowledge: even murder is necessary.
In this play the conflict between father and son is occasioned by
the father's insanity and monstrous engineering visions; the
scientific interpretation of life is rejected and superseded by the
struggle towards spiritual regeneration. The form of *Der Bettler*
owes much to Strindberg: the characters are nameless, the scene
with the pilots and the prostitutes verges upon a nightmare. The
chorus-like chanting, the harsh spotlighting and grouping of

characters deliberately stress the movement away from naturalist drama.

But the play which became the central expression of revolt in the theatre was Hasenclever's *Der Sohn (The Son)*, written after Sorge's play but performed one year earlier, in 1916. Like *Der Bettler*, Hasenclever's play is constructed formally along traditional lines, but the mixture of dramatic prose and blank verse reflects an intensely-expressed vision, an emphasis on fervour and hyperbole. Again the characters are not named: we learn of the Son who is tyrannized by the Father, of the Friend who lures him into life, and the Governess who watches his revolt with trepidation and hope. 'Man lebt nur in der Ekstase, die Wirklichkeit würde einen verlegen machen' ('We only live in ecstasy, reality would embarrass us!') cries the young man, full of Nietzschean *Pathos* and Faustian desires; rescued by his friends (to the strains of Beethoven's Ninth Symphony) he joins a revolutionary organization demanding the death of fathers, the brutalization of the ego, and a Dionysian frenzy. The Friend gives him a revolver to commit parricide: the final confrontation between father and son is one of extreme tension, but the actual act of murder is spared by the father's death of a stroke. In another play, however, Arnolt Bronnen's *Vatermord (Parricide)* (written in 1915 and performed in uproar in 1922) the act of murder is perpetrated in a paroxysm of hatred; the theme of incest also plays an important part. Further violence is rife in Paul Kornfeld's *Die Verführung (The Seduction)*, written in 1913, which, in exalted prose, shows how the rebellious youth murders a man he has never met before simply because he seems to embody the oppressive spirit of the age. The intensity of the revolt is also seen in Hanns Johst's *Der junge Mensch. Ein ekstatisches Szenarium (The Young Man: An ecstatic scenario)* which bears the motto: 'Es ist eine rasende Wollust: jung sein und um die Verzückung des Todes wissen' ('This is raving voluptuousness – to be young, and to know of

the raptures of death'). Wedekind is very much in evidence in
this play, particularly in the classroom scenes and in the ending
in the cemetery where the Young Man, dead and buried, leaps
across the cemetery wall at the audience, reborn and emerging
from the old self. Much influenced by Hasenclever's *Der Sohn*
is Anton Wildgans's *Dies Irae* (written in 1918), which culminates
in the suicide of the young hero, whose fatal conflict with his
father finally destroyed his life; act five, the 'Actus quintus
fantasticus', consists of a 'chorus puerorum et adolescentium',
where the Friend, as 'choragetes', summons the father to a final
judgement. The hymn-like pathos comes to a climax in a blaze
of frenzy at the end: 'O die den Menschen zeugen/Nicht um
des Menschen willen,/Ihrer die Schuld!! Weh! Weh! Weh!'
('They who create Man, not for the sake of Man, they are the
guilty ones!! Woe! Woe! Woe!') A 'Vox patrise tenebris infimis'
proclaims 'Posaunen! Posaunen! Posaunen!' ('The last trump!
The last trump! The last trump!') and 'Voces apocalypticae de
coelis cantantes' declaim the 'Dies irae, dies illa'.

In so many of these plays the father represents authority,
discipline and order, an order which is stultifying and ultimately
destructive, for it stifles the passionate life of the young man
who longs to hold all in a passionate embrace. Criticism of
parental authority implied also the criticism of military academies
and educational establishments: Gottfried Benn's short play
Ithaka, published in the periodical *Die weißen Blätter* in Leipzig,
1914, ends with the students seizing the professor by the throat,
beating him about the head, and shouting: 'Wir wollen den
Traum. Wir wollen den Rausch. Wir rufen Dionysos und
Ithaka!' ('We want dream, we want ecstasy, we call upon Dionysus
and Ithaca!'). But the revolt portrayed in so many of these works
has virtually no constructive motives: it is pure self-expression.
The feverish desire for life is akin to a death-intoxication: vitalism
is not necessarily a sign of health, but can spring from deep

uncertainty, even neuroses. There is an undeniable atavism about much of this attitude, a primitivism and dangerous instability which became more and more apparent in German history. As well as irrational violence there is also in many of the works of this time an almost religious fervour, seen at the end of *Dies Irae* and also Kornfeld's *Himmel und Hölle* (1919), an operatic drama where the temptation of nihilism is overcome by a vision of love and self-sacrifice for humanity. An element of mysticism emerges, which lies at the heart of expressionism, with its emphasis on fervour and subjectivity: the religious quality is seen at its purest in the plays of Ernst Barlach (whose sculpture 'Der Ekstatiker' is as quintessentially expressionist as is Munch's 'The Shriek'). In 1912 Barlach wrote *Der tote Tag* (*The Dead Day*), a ghostly, mythical work, a dramatic exploration of the interaction of supernatural forces, some grotesque and menacing, others benign. Here it is the Father-principle which is divine and free: the boy's longing for the Father, for transcendence, is thwarted by the Mother, who represents the earth-bound and the immanent. In Barlach's mystical world of goblins, mist and nightmares the Son must assert himself and seek the Father: although he perishes the knowledge is gained that God is the Father of man. In his next play, *Der arme Vetter* (*The Poor Cousin*) (1918), Barlach starts with a realistic milieu, but moves towards mystery and ultimate redemption with his portrayal of 'die wachsende Ex-karnation des wesenhaften Menschen', 'the growing excarnation of essential man'.

The German stage, then, with its treatment of revolt, violence and mysticism, clearly demonstrated, even before the outbreak of the First World War, the new outlook which can be called expressionist. But another art-form, even more suitable for the expression of turbulent emotion, disquiet and unreality, was the lyric, and an important name here is Herwarth Walden (i.e. Georg Levin), editor of the vitally important periodical *Der*

Sturm. Founded as a weekly in Berlin in 1910, this journal played a major role in pioneering the new outlook: in that year it published Kokoschka's drawings and in the following year it printed Marinetti's *Futurist Manifesto*. In March 1912 Walden opened the journal's own gallery, and his interest shifted increasingly towards the visual arts, although Guillaume Apollinaire contributed 'Zone' in French, and the poet August Stramm (1874–1915) proved a major literary discovery. The *Sturm* circle in Berlin also inspired similar ventures: in 1910 Kurt Hiller founded his *Neopathetisches Cabaret*, with which were associated the poets Blass (1890–1939), Lichtenstein (1889–1914) and Jakob van Hoddis (1887–1942?). It has been claimed that German literary Expressionism began with the publication in a further journal, *Die Aktion* (founded in Berlin by Franz Pfemfert in 1911), of the poem 'Weltende' ('End of the World') by van Hoddis, followed soon after by Alfred Lichtenstein's 'Die Dämmerung' ('The Twilight').

These two poems are good examples of the poetic modernity described in Chapter 2; Michael Hamburger describes them thus: 'What was new about them is that they consisted of nothing more than an arbitrary concatenation of images derived from contemporary life; they presented a picture, but not a realistic one . . . They were a kind of *collage* . . .' (*Reason and Energy*, p. 222). They do not attempt to reflect a meaningful order, but *express* the poet's sense of the vulnerability and disharmony in the world. The poems are formally quite conventional, but convey a disturbing sense of *malaise* which borders upon the bizarre: the tension between regular metres and irregular vision is most effective.

Weltende reads as follows:

> Dem Bürger fliegt vom spitzen Kopf der Hut,
> In allen Lüften hallt es wie Geschrei,
> Dachdecker stürzen ab und gehn entzwei
> Und an den Küsten – liest man – steigt die Flut.

Der Sturm ist da, die wilden Meere hupfen
An Land, um dicke Dämme zu zerdrücken.
Die meisten Menschen haben einen Schnupfen.
Die Eisenbahnen fallen von den Brücken.

(The hat flies from the burgher's pointed head,/In all the skies there seems a fearful scream,/The tilers fall from roofs and break in half,/ And at the coast – we read – the tide is high./The storm is here, the wild seas bound/On to the land, to break the solid dams./Most people have a cold./The railway lines fall from the bridges.)

and 'Die Dämmerung' is similar:

Ein dicker Junge spielt mit einem Teich.
Der Wind hat sich in einem Baum gefangen.
Der Himmel sieht verbummelt aus und bleich,
Als wäre ihm die Schminke ausgegangen.

Auf lange Krücken schief herabgebückt
Und schwatzend kriechen auf dem Feld zwei Lahme.
Ein blonder Dichter wird vielleicht verrückt.
Ein Pferdchen stolpert über eine Dame.

An einem Fenster klebt ein fetter Mann.
Ein Jüngling will ein weiches Weib besuchen.
Ein grauer Clown zieht sich die Stiefel an.
Ein Kinderwagen schreit und Hunde fluchen.

(A fat boy is playing with a pond./The wind has become tangled in a tree./ The sky looks pale and debauched/As though its make-up had run out./On long crutches, crookedly bent, and chatting,/Two cripples crawl about a field./Perhaps a fair poet will become insane./ A pony stumbles over a lady./A fat man is sticking to a window./ A youth wishes to visit a soft woman./A grey clown pulls on his boots./A pram screams, and dogs curse.)

The syntactical compression, sense of the bizarre and dream logic of these two poems is one aspect of expressionism; the caricature-apocalypse à la Hoddis and the more ironic urban sense of discomfort adumbrated by Lichtenstein gave way gradually to a general sense of doom in many poets. The famous anthology of

German Expressionist verse, *Menschheitsdämmerung*, (*Dawn* [*or dusk?*] *of Mankind*), which was edited by Kurt Pinthus and which appeared in 1920, seemed to prophesy a new millennium, but the chiliastic overtones are very much apparent. A further sense of disaster is apparent in the poetry of Georg Heym who died in a skating accident in 1912 at the age of twenty-four. Again, in Heym's case the syntax is conventional, but the dynamic imagery has an expressive power which transcends mere description; the poems 'Der Gott der Stadt' ('The God of the City'), 'Die Dämonen der Städte' ('The Demons of the Cities') and 'Umbra Vitae' portray in hyperbolic images the monstrous horror of life in great cities, where sickness, deformity and death are all that man can know. At this time the city of Berlin came more and more to amaze and horrify several of the young German Expressionist poets, with its size and fearful indifference to suffering. A writer such as Gottfried Benn was cynical in his view of man and his modernity (Georg Grosz well illustrated many of Benn's themes), and Bert Brecht frequently followed Marinetti in his admiration for the machine and the technology of the cities. But Georg Heym and, to a lesser extent Georg Trakl, were filled with dread at the plight of man trapped within the asphalt labyrinth. Heym's tendency to mythologize is seen very clearly in his town poetry, but is probably most effective of all in the apocalyptic and prophetic *Der Krieg* ('War'), written in 1912, whose first three stanzas run as follows:

> Aufgestanden ist er, welcher lange schlief,
> Aufgestanden unten aus Gewölben tief.
> In der Dämmerung steht er, groß und unbekannt,
> Und den Mond zerdrückt er in der schwarzen Hand.

> In den Abendlärm der Städte fällt es weit,
> Frost und Schatten einer fremden Dunkelheit.
> Und der Märkte runder Wirbel stockt zu Eis.
> Es wird still. Sie sehn sich um. Und keiner weiß.

In den Gassen faßt es ihre Schulter leicht.
Eine Frange. Keine Antwort. Ein Gesicht erbleicht.
In der Ferne zittert ein Geläute dünn,
Und die Bärte zittern um ihr spitzes Kinn . . .

(He has arisen, the one who has slept long,/He has arisen from deep
vaults below./He stands in the dusk, large, unknown/And he crushes
the moon in his black hand./Far into the evening noise of the town
there falls/The frost and shadow of a strange darkness./The round
whirling of the markets freezes to ice./It becomes still. They look
around. And no one knows./In the narrow streets it lightly touches
their shoulders./A question. No answer. A face grows pale./In the
distance there is a thin, tremulous ringing,/And their beards tremble
round their pointed chins . . .)

The first stanza of this poem has become famous in anthologies of
German Expressionist verse, with its dynamic verb at the begin-
ning of the sentence and the powerful image of War 'crushing
the moon in his black hand'. The expressionist tendency to see
through the surface of things to behold a mythical, archetypal
vision is well represented here; a statement by the writer Kasimir
Edschmid (i.e. Eduard Schmid) in 1917 explains that, although
the expressionist may take the same themes as the naturalist,
there is a vast difference; 'So wird der Raum des expression-
istischen Künstlers Vision. Er sieht nicht, er schaut. Er schildert
nicht, er erlebt. Er gibt nicht wieder, er gestaltet. Er nimmt
nicht, er sucht. Nun gibt es nicht mehr die Kette der Tatsachen:
Fabriken, Häuser, Krankheit, Huren, Geschrei und Hunger. Nun
gibt es die Vision davon' (*Expressionismus*, dtv, p. 96): ('The
space of the expressionist artist, then, becomes vision. He does
not see, he looks. He does not describe, he experiences. He does
not reproduce, he forms. There is no longer the chain of facts:
factories, houses, sickness, whores, screams, and hunger. Now
there is the vision of this'). The expressionists, Edschmid suc-
cinctly comments, do not take photographs, but have visions;

imitation of nature is totally rejected in favour of fervent subjectivity.

In Heym the vision is eschatological; in a poet like Ernst Stadler, killed in 1914, there is a vitalism akin to that of Walt Whitman. Stadler's surging lines of poetry and his rushing sweep of self-generating images also betray a dithyrambic passion akin to Nietzsche's; there is also, however, a humanitarian concern in his poetry, not as rhapsodic as Werfel's, but nevertheless moving and sincere. (His excursions into the East End of London filled him with horror and his poem 'Ballhaus' portrays the dawn and the new, ringing song of the workers which cuts through the stale air of the degenerate ballroom.) His masterpiece is indubitably 'Fahrt über die Kölner Rheinbrücke bei Nacht' ('Nightjourney across the Rhine bridge at Cologne'), a poem whose imagery is realistic, yet which is shot through with a subjective passion which gives a vast extension to its meaning. There is an ecstasy, yet also a movement towards dissolution, a soaring flight of the imagination which culminates in a vision of the sea, the flux and turmoil of existence itself. Regular syntax is abandoned here, and the lines swell to an almost Klopstock-like splendour:

Der Schnellzug tastet sich und stößt die Dunkelheit entlang.
Kein Stern will vor. Die ganze Welt ist nur ein enger,
 nachtumschienter Minengang,
Darein zuweilen Förderstellen blauen Lichtes jähe Horizonte
 reißen: Feuerkreis
Von Kugellampen, Dächern, Schloten, dampfend, strömend ...
 nur sekundenweis ...
Und wieder alles schwarz. Als führen wir ins Eingeweid der
 Nacht zur Schicht.
Nun taumeln Lichter her ... verirrt, trostlos vereinsamt ...
 mehr ... und sammeln sich ... und werden dicht.
Gerippe grauer Häuserfronten liegen bloß, im Zwielicht bleichend,
 tot – etwas muß kommen ... o, ich fühl es schwer

Im Hirn. Eine Beklemmung singt im Blut. Dann dröhnt der Boden
 plötzlich wie ein Meer:
Wir fliegen, aufgehoben, königlich durch nachtentrißne Luft, hoch
 übern Strom. O Biegung der Millionen Lichter, stumme Wacht,
Vor deren blitzender Parade schwer die Wasser abwärts rollen.
 Endloses Spalier, zum Gruß gestellt bei Nacht!
Wie Fackeln stürmend! Freudiges! Salut von Schiffen über blauer
 See! Bestirntes Fest!
Wimmelnd, mit hellen Augen hingedrängt! Bis wo die Stadt mit
 letzten Häusern ihren Gast entläßt.
Und dann die langen Einsamkeiten. Nackte Ufer. Stille. Nacht.
 Besinnung. Einkehr. Kommunion. Und Glut und Drang
Zum Letzten, Segnenden. Zum Zeugungsfest. Zur Wollust.
 Zum Gebet. Zum Meer. Zum Untergang.

(The express train gropes and pushes along the darkness. No star
wishes to come. The whole world is only a narrow mine-gallery,
railed in by night, into which sudden skylines are torn by hauling-
shafts of blue light; a fiery circle of light-globes, roofs, chimneys,
smoking, streaming, only for moments . . . then all is black again.
As though we were off on our shift into the very bowels of night.
Now lights stagger towards us . . . lost, inconsolable, isolated . . .
more . . . and gather . . . and grow dense. Skeletons of grey house-
fronts are exposed, pallid in the half-light, dead – something must
come . . . oh, I feel it, pressing, in my brain. An oppression sings in
my blood. Then the ground booms suddenly like the sea: we are
flying, suspended, king-like through air torn from the night, high
above the river. Oh the curving of millions of lights, the silent sentry
before whose glittering parade the waters roll heavily downwards . . .
Endless cordon, posted as a greeting by the night! Rushing like
torches! Joyful being! The salute of ships across the blue sea! A
festival of stars! Teeming, pushed onwards with bright eyes! Until
where the city with its last houses leaves its guest. And then the long
stretches of loneliness. Bare shores. Silence. Night. Reflection.
Return. Communion. And the glow, the urge towards the ultimate,
the blessing one. To the feast of creation. To ecstasy. To prayer. To
the sea. To extinction.)

As Michael Hamburger explains: 'Because of their extreme dynamism, his [Stadler's] poems have a rhetorical effect; but it is private rhetoric, as it were, not aimed at the reader in the manner of Werfel and many of the later Expressionists. Only his excellent craftsmanship saved Stadler from other dangers. Few poets would have got away with the long succession of a-syntactic words – most of them abstract and general – in the last two lines . . . Stadler brings off these verbal and mental leaps, just as he manages to keep his long line from spilling over into prose, and makes his rhymes all the more effective for being delayed' (*Reason and Energy*, p. 230). The poem 'Anrede' ('Salutation') uses a Nietzschean imagery (flame, thirst, scream and fire) which later became debased in the hands of less skilful poets; the most effective 'Form ist Wollust' ('Form is Rapture') is more conventional in form than the 'Fahrt über die Kölner Rheinbrücke', but is an exact statement of Stadler's belief, an expressionist creed *in nucleo*:

> Form und Riegel mußten erst zerspringen,
> Welt durch aufgeschloßne Röhren dringen:
> Form ist Wollust, Friede, himmlisches Genügen,
> Doch mich reißt es, Ackerschollen umzupflügen.
> Form will mich verschnüren und verengen,
> Doch ich will mein Sein in alle Weiten drängen –
> Form ist klare Härte ohn' Erbarmen,
> Doch mich treibt es zu den Dumpfen, zu den Armen,
> Und in grenzenlosem Michverschenken
> Will mich Leben mit Erfüllung tränken.

(Form and bolt had to burst, world had to force its way through opened pipes; form is ecstasy, peace, divine contentment, yet I feel I must plough up the clods of earth. Form wants to strangle, to contain me, yet I want to force my being in all directions – form is clear hardness without pity, yet I am driven to the dull, the poor, and in the limitless giving of myself life will fill me with fulfilment.)

It is also Stadler's 'Der Spruch' ('The Motto') which contains the quintessential line 'Mensch, werde wesentlich!' – virtually untranslatable, but which has the meaning: Man, know your essence and live it to the full!

The poetry of Ernst Stadler exhibits one aspect of expressionist verse, which may be called the dithyrambic-rhetorical method: that of August Stramm, killed in 1915, is at the other pole, that of intense concentration. A subjective, inner state is expressed in a form of words which approximate to an abstract picture; neologisms intensify the impression of an unreality which paradoxically conveys a powerful truth. Stramm seems concerned to express absolute essence: adjectives and visual images are superfluous to this. 'Trieb' ('Urge') and 'Schwermut' ('Melancholy') are good examples of his experiments:

> Schrecken Sträuben
> Wehren Ringen
> Ächzen Schluchzen
> Stürzen
> du!
> Grellen Gehren
> Winden Klammern
> Hitzen Schwächen
> ich und du!
> Lösen Gleiten
> Stöhnen Wellen
> Schwinden Finden
> ich
> dich
> du!

(Frightening struggling/Protecting wrestling/Groaning sobbing/Plunging/you!/Piercing lusting/Writhing clutching/Heats weakenings/I and you!/Loosening, gliding/Moaning waves/Fading finding/I/you/you!)

Schreiten Streben
Leben sehnt
Schauern Stehen
Blicke suchen
Sterben wächst
Das Kommen
Schreit!
Tief
Stummen
Wir.

(Striding striving/Living longs/Shuddering standing/Glances seek/
Dying grows/The coming/Screams!/Deep/Dumb are/We.)

The intensity and sincerity of Stramm's method may not be
doubted, but the dangers are obvious: in the hands of lesser poets
such stammering concentration could, and did, become pretentious
and ludicrous, particularly when such words as God, Man, Chaos,
Death, Goodness and Spirit are used indiscriminately. Later it
was the Dadaist poets who used this method and deliberately
reduced all to absurdity, and perhaps this is preferable to its
use by an earnest but mediocre poetaster.

Both Stadler and Stramm are innovators, the latter being
particularly extreme in his rejection of conventional verse forms;
compared with their poetry, that of the Austrian Georg Trakl,
who committed suicide in 1914, appears traditional, with its
frequent use of the sonnet. But Trakl's moonlit, autumnal death-
landscapes of the soul betray a most original use of metaphor
and image, whose expressive powers are remarkable. Walter
Sokel explains: 'The Austrian poet Georg Trakl represents in
Expressionist poetry an equivalent to Kandinsky's role in Expres-
sionist painting. Just as Kandinsky creates pure compositions of
colors and lines, so Trakl creates pure compositions of autonomous
metaphors . . . Trakl's poetry is not a system of communication
of ideas, but a flight of images, or autonomous metaphors,

resembling an incoherent dream' (*Writer in Extremis*, p. 49). Trakl's poetry most effectively marks the transition from the passive receptivity of impressionism to a more dynamic, expressive use of metaphor: description gives way to expression. The juxtaposition of apparently disparate images is the characteristic of Trakl's poetry which fascinates, puzzles and alienates the reader, as does the ambiguity between image-as-metaphor and image-as-symbol. Similarly the use of colour-epithets makes understanding difficult: are the colours symbolic or merely evocative? The poem 'Siebengesang des Todes' ('The Sevenfold Song of Death') is a good example of his art:

> Bläulich dämmert der Frühling; unter saugenden Bäumen
> Wandert ein Dunkles in Abend und Untergang,
> Lauschend der sanften Klage der Amsel.
> Schweigend erscheint die Nacht, ein blutendes Wild,
> Das langsam hinstirbt am Hügel.
>
> In feuchter Luft schwankt blühendes Apfelgezweig,
> Löst silbern sich Verschlungenes,
> Hinsterbend aus nächtigen Augen; fallende Sterne;
> Sanfter Gesang der Kindheit.
>
> Erscheinender stieg der Schläfer den schwarzen Wald hinab,
> Und es rauschte ein blauer Quell im Grund,
> Daß jener leise die bleichen Lider aufhob
> Über sein schneeiges Antlitz;
>
> Und es jagte der Mond ein rotes Tier
> Aus seiner Höhle;
> Und es starb in Seufzern die dunkle Klage der Frauen.
>
> Strahlender hob die Hände zu seinem Stern
> Der weiße Fremdling;
> Schweigend verläßt ein Totes das verfallene Haus.
>
> O des Menschen verweste Gestalt: gefügt aus kalten Metallen,
> Nacht und Schrecken versunkener Wälder
> Und der sengenden Wildnis des Tiers;
> Windesstille der Seele.

Auf schwärzlichem Kahn fuhr jener schimmernde Ströme hinab,
Purpurner Sterne voll, und es sank
Friedlich das ergrünte Gezweig auf ihn,
Mohn aus silberner Wolke.

(Bluish the Spring grows dusk; beneath sighing trees a dark one
wanders into evening and decline, listening to the soft lament of the
blackbird. Silent appears the night, a bleeding wild animal, that
slowly dies along the hill. In moist air sway blossoming apple
branches; that which is tangled separates silverly, dying away from
nocturnal eyes; falling stars; the gentle song of childhood. The
sleeper appears more radiant along the dark forest, and a blue spring
rushes in the hollow, that one should raise his pale eye-lids above
his snow-like countenance. And the moon drove a red beast from its
cave, and the dark lament of women dies into sighs. The white
stranger, more gleaming, lifted his hands to his star; silently a dead
thing left the derelict house. Oh the putrified form of man; forged
from cold metals, night, and the terrors of sunken forests, and the
singeing wildness of the beast; doldrums of the soul. On a black
canoe that one sailed down shimmering streams, full of purple stars,
and the green branches sank peacefully on to him, poppy from a
silver cloud.)

The remote, luminous world portrayed here, the shadowy
neutral substantives and the hermetic correspondences are akin to
the world of the symbolist; the use of colours and powerful images,
however, places Trakl without doubt among the expressionist
poets. There is no bombast, no rhetoric, but a haunting euphony
in almost all that he wrote: the problem of the big city is only
occasionally found. But a sense of evil links him with Heym, and
the apocalyptic note breaks through in the last poems, in jagged,
terrible visions:

> Dich sing ich wilde Zerklüftung,
> Im Nachtsturm
> Aufgetürmtes Gebirge;
> Ihr grauen Türme

Überfließend von höllischen Fratzen,
Feurigem Getier,
Rauhen Farnen, Fichten,
Kristallnen Blumen.
Unendliche Qual,
Daß du Gott erjagtest
Sanfter Geist,
Aufseufzend im Wassersturz,
In wogenden Föhren.

Golden lodern die Feuer
Der Völker rings.
Über schwärzliche Klippen
Stürzt todestrunken
Die erglühende Windsbraut,
Die blaue Woge
Des Gletschers
Und es dröhnt
Gewaltig die Glocke im Tal:
Flammen, Flüche
Und die dunklen
Spiele der Wollust,
Stürmt den Himmel
Ein versteinertes Haupt.

(Wild fragmentation, I sing you, in nocturnal storm, in piled up mountains; you grey towers bursting with hellish faces, fiery beasts, rough ferns, pines, crystal flowers. Unending torment, that you should hunt down God, gentle spirit, sighing in the water-fall, in waving pines. Gold gleam the fires of peoples round about, over blackish cliffs, drunk with death, rushed the glowing storm, the blue wave of the glacier, and the bell hammers powerfully in the valley; flames, curses, and the dark games of lust; a petrified head storms heaven.)

And that which Trakl and Heym had foreseen came to pass: On 28 July Austro-Hungary declared war on Serbia, and within a week the whole of Europe was in arms.

* * *

From this brief account of the German cultural condition before 1914 it must be apparent that both the theatre and lyric poetry moved away from nineteenth-century models towards a more dynamic, unstable and intensely subjective mode of expression. The novel was less obviously involved in the new ferment: the stream of consciousness technique which marks the new direction in that genre owes much to the *Sekundenstil* of the Naturalists and often seems a continuation of impressionist (or 'pointilliste') practice. If 'expressionism', as Malcolm Pasley has written, also refers to the predilection for attack against Wilhelmine society, then the novels of Heinrich Mann would qualify from the point of view of subject matter, although their form is mostly conventional; the abnormal intensity of many of the characters in the work of Jakob Wassermann seems reminiscent of the Dostoevsky-quality of much expressionist writing, and hence are worthy of mention. But unlike Naturalism, where the novel was of paramount importance, the expressionist mentality found a more appropriate outlet in other forms.

Developments in literature and painting ran parallel: Kandinsky and Kokoschka demonstrated how closely linked the two arts were at this time. There were also close ties between Schoenberg and the *Blaue Reiter* group; Kandinsky discussed Schoenberg's paintings and in 1912 published his 'Arnold Schönberg in höchster Verehrung' ('Homage to Arnold Schoenberg'). In 1909 Schoenberg composed his *Erwartung (Expectation)*, a sombre monodrama full of hallucinatory violence, an eruption from the subconscious; his *Die glückliche Hand (The Fortunate Hand)*, finished in 1913, with its Man, Woman, Gentleman and chorus, together with the symbolic use of colours and lighting, seems to stem from Strindberg and Kokoschka: the struggle of the artist to free himself from woman and society is a worthy expressionist theme. Other links between music and literature are found in Berg's setting of Trakl's poems and particularly in his two operas *Wozzeck* and

Lulu, the former being recognized as the standard work of musical expressionism, a fiercely dramatic portrayal of a tormented soul. This was not put on until 1925, but Büchner's haunting work had occupied Berg for many years. *Lulu* was likewise not started until 1928, although Berg had seen Wedekind's play *Pandora's Box* in 1905. The same year saw the performance of Richard Strauss's *Salomé* in Dresden, followed four years later by *Elektra*, two operas which push tonal expressiveness towards an undreamt-of intensity. Music, painting and literature were moving forward to a new energy, a new aggressiveness even, and German Expressionism was in the vanguard.

4
The German Situation between 1914 and the Mid-Twenties

It is often mistakenly believed that expressionism, in St John Ervine's words [Willet, p. 173], was simply 'the despair and neurosis of a defeated people', a movement of intellectual crisis originating during the First World War and its aftermath. This is an unsatisfactory definition, as it has been shown that anti-naturalistic devices, attacks against society, and rhapsodic, expressive forms of writing were found in Germany and elsewhere long before 1914. But it is also true that the war did bring to a head certain latent predispositions and characteristics which lent German Expressionism its particular intensity and dimension, and in the early twenties the expressionist tendencies in Germany reached an unusual and often febrile proportion.

Before 1914 the young German writers who may be called Expressionists frequently portrayed an isolated individual struggling to give expression to the life force within him: this may be termed the Nietzschean element. The highest form of existence is glimpsed in glowing incandescence, whilst the meaninglessness of modern life is to be rejected as mere dross. The political orientation of this fervour was not yet apparent, although 1913 saw the appearance of the periodical *Revolution*, in which the poet Erich Mühsam proclaimed:

Alle Revolution ist aktiv, singulär, plötzlich und ihre Ursachen
 entwurzelnd . . . Einige Formen der Revolution: Tyrannenmord,
Absetzung einer Herrschergestalt, Etablierung einer Religion,

Zerbrechen alter Tafeln (in Konvention und Kunst), Schaffen
eines Kunstwerks, der Geschlechtsakt.
Einige Synonyma für Revolution: Gott, Leben, Brunst, Rausch,
Chaos.
Laßt uns chaotisch sein!

(All revolution is active, singular, sudden, uprooting its causes . . .
Some forms of revolution: tyrannicide, deposition of a ruling figure,
the establishment of a religion, the destruction of the old tablets (in
convention and art), the creation of an art-work, the sexual act. A
few synonyms for revolution: God, Life, Lust, Intoxication, Chaos.
Let us be chaotic!)

But the desire to be chaotic frequently seemed to bring with it
an apocalyptic sense of disaster, and crisis is never far from the
scene: the expressionist shriek, as was earlier explained, is one of
ecstasy *and* despair. In his *Expressionismus*, finished in 1914 and
published two years later, the Austrian Hermann Bahr summed
up the situation thus: 'Der Mensch schreit aus seiner Seele, die
ganze Epoche wird ein einziger, dringender Schrei. Die Kunst
schreit auch, in die tiefe Finsternis, schreit nach Hilfe, schreit
nach dem Geist. Das ist Expressionismus' ('Man screams from
the depths of his soul, the whole age becomes one single, piercing
shriek. Art screams too, into the deep darkness, screams for help,
for the spirit. That is expressionism').

The need for a New Vision, a New Reality, a New Man – these
are the watchwords. Yet the European nations were locked in
bloody strife, and the losses were appalling: in 1914 alone Stadler,
Lichtenstein, the poet Ernst Lotz and August Macke were killed,
and Trakl committed suicide after seeing the carnage at Grodek;
August Stramm was killed in 1915; in 1916 Franz Marc, Reinhard
Sorge and the writer Gustav Sack fell; in 1918 the poet Gerrit
Engelke died shortly before the armistice. The intellectuals who
survived the war or who fled to Switzerland realized that the
Wilhelmine order in Germany had to be overthrown before a

new world could emerge; suffering was the crucible in which a new sense of brotherhood and solidarity was to be formed. A spiritual feeling of brotherhood seized many of the younger writers, and prepared the way for the political activism which rose to the surface at the end of the war.

The name of Franz Werfel emerges here, whose rhapsodic style, tending towards bombast, exemplified the fervent poetry written at this time. His anthology *Der Weltfreund* (*Friend of the World*) had, in fact, appeared in 1911, but was read widely during the war and reissued in 1920. The poem 'An den Leser' well expresses the new mentality:

> Mein einziger Wunsch ist, Dir, o Mensch verwandt zu sein!
> Bist Du Neger, Akrobat, oder ruhst Du noch in tiefer Mutterhut,
> Klingt Dein Mädchenlied über den Hof, lenkst Du Dein Floß im
> Abendschein,
> Bist Du Soldat, oder Aviatiker voll Ausdauer und Mut . . .
> Denn ich habe alle Schicksale durchgemacht . . .
> So gehöre ich Dir und allen!
> Wolle mir, bitte, nicht widerstehn!
> O, könnte es einmal geschehn,
> Daß wir uns, Bruder, in die Arme fallen!

(My only desire, oh Man, is to be related to you! Whether you are a negro, an acrobat, or whether you are still resting deep in a mother's womb, whether your maiden's song echoes across the yard, whether you are steering your raft in the evening sunshine, whether you are a soldier, or airman, full of stamina and courage . . . For I have experienced all the destinies . . . So I belong to you, and to all! Please, do not refuse me! Oh, could it but once happen that, Brother, we fall into each other's arms!)

A hymn to Man, 'Lächeln Atmen Schreiten' ('Smiling Breathing Striding') was published in 1916 and proclaims that Man is the Creator of all, that the human spirit is the ultimate essence and meaning of all existence; another good example of

Werfel's verse is 'Veni creator spiritus', a plea for ecstasy and rapture that will destroy all limitations and drive all men into a joyous embrace:

> Komm, heiliger Geist, Du schöpferisch!
> Den Marmor unsrer Form zerbrich!
> Daß nicht mehr Mauer krank und hart
> Den Brunnen dieser Welt umstarrt,
> Daß wir gemeinsam und nach oben
> Wie Flammen ineinander toben!
> ...
> Daß tränenhaft und gut und gut
> Aufsiede die entzückte Flut,
> Daß nicht mehr fern und unerreicht
> Ein Wesen um das andre schleicht,
> Daß jauchzend wir in Blick, Hand, Mund und Haaren,
> Und in uns selbst Dein Attribut erfahren!
>
> Daß, wer dem Bruder in die Arme fällt,
> Dein tiefes Schlagen süß am Herzen hält,
> Daß, wer des armen Hundes Schaun empfängt,
> Von Deinem weisen Blicke wird beschenkt,
> Daß alle wir in Küssens Überflüssen
> Nur Deine reine heilige Lippe küssen!

(Come, Holy Ghost, creative spirit! Shatter the marble of our form, that a sick, hard wall should no longer stand rigid around the well of this world, that together, upwards, we may rush like flames into each other! . . . That tearfully and good, good, the ecstatic flood may seethe upwards, so that no longer beings should creep around each other, far and isolated, so that joyfully with looks, hand, mouth and hair we should recognize your attributes! So that who ever falls into a brother's arms may feel your sweet beating against his heart, so that whoever catches the look of some poor dog also receives the wisdom of your glance, so that all of us, in a profusion of kisses, may only kiss your pure, holy lips!)

Such windy rhetoric can easily degenerate into bathos; the more jubilant the shouts of ecstasy become, the more unreadable

becomes the poetry. Johannes Becher, later to become Minister
of Culture in East Germany, became famous for such chaotic
outbursts as 'Der Mensch steht auf!' ('Man arises!'):

Verfluchtes Jahrhundert! Chaotisch! Gesanglos! Ausgehängt du
 Mensch, magerster der Köder, zwishen Qual Nebel-Wahn Blitz.
Geblendet. Ein Knecht. Durchfurcht. Tobsüchtig. Aussatz und
 Säure.
Mit entzündetem Aug. Tollwut im Eckzahn. Pfeifenden Fieberhorns.
Aber
Über dem Kreuz im Genick wogt mild unendlicher Äther.
Heraus aus Gräben Betrieben Asylen Kloaken, der höllischen
 Spelunke!
Sonnen-Chöre rufen hymnisch auf die Höhlen-Blinden.
Und
Über der blutigen Untiefe der Schlachten-Gewässer
Sprüht ewig unwandelbar Gottes magischer Stern.
. . .
Sage mir, o Bruder Mensch, wer bist du?!
Wüter. Würger. Schuft und Scherge.
Lauer-Blick am gilben Knochen deines Nächsten.
König Kaiser General.
Gold-Fraß. Babels Hure und Verfall.
Haßgröhlender Rachen. Praller Beutel und Diplomat.
Oder oder
Gottes Kind!!??
. . .
Noch noch ist's Zeit!
Zur Sammlung! Zum Aufbruch! Zum Marsch!
Zum Schritt zum Flug zum Sprung aus kananitischer Nacht!!!
Noch ist's Zeit –
Mensch Mensch Mensch stehe auf stehe auf!!!

(Cursed century! Chaotic! Songless! You, Man, most wretched of
baits, suspended between torment fog-madness lightning. Blinded.
A serf. Lacerated. Leprosy and acid. With enflamed eye. Rabies in
the fang. Whistling fever-horn. But – above the cross in the neck

there wafts a mild and infinite aether. Come – out of the graves the offices the institutions the cess-pits, the hellish dens! Sun choruses call hymn-like to the cave-blinded. And – above the bloody depths of the battle-waters there sparkles eternal and unchangeable God's magic star . . . Tell me, brother man, what are you? Raving one. Murderer. Wretch and hangman. A lurking glance at the yellowed bone of your neighbour. King Emperor General. Gold devourer. Whore of Babylon. Decay. With throat of growling hatred, money-bag, diplomat. Or – or – *Child of God*!!?? There is still time! To the meeting, the departure, the march! To the step, the flight, the leap from the night of Canaan! There is still time! Man, man, man, arise, arise!!!)

The sentiments may be admirable, but the poetry is execrable: the exclamation marks proliferate and the stammering formlessness and hyperbolic declamation lapse into the absurd. But Becher is by no means alone in his visionary fervour and his proclamation of the greatness of man; as the war came to its end the atmosphere of millennial expectancy and revolutionary rapture grew to white heat. Becher may represent German Expressionist longing at its most pretentious and inflated, but an infinitely greater craftsman, Georg Kaiser, was, on the German stage, working out his vision of the New Man in a language which was a remarkable fusion of the cerebral and the passionate. There is no 'Oh Man!' pathos in Kaiser, but a zealous fervour contained within lucid, mathematical precision.

Georg Kaiser is a remarkable phenomenon in theatrical history. At the height of his creative power, and during the climax of German Expressionism, that is, between 1917 and 1923, twenty-four plays by him were performed on the German stage. His plays are above all plays of ideas, of dialectical progression: his compressed, staccato language is a perfect tool to describe the clash of concepts. Kaiser, the *Denkspieler*, sat at his steel writing desk and worked out with ruthless and brilliant logic a dramatic dialogue which thrills the listener with the exhilaration of logical

clash and resolution. To write drama, for Kaiser, is to follow a thought to its conclusion, yet thinking is also, for him, full of passion and vitality: his intense idealism was directed towards one vision – the Regeneration of Man. Seeing the dangers of bombast and rodomontade he insisted upon clarity, upon a steely yet flexible beauty; there is nothing nebulous or specious in his work. The famous *Telegramstil* reduces argument to bare essentials, to absolute essence, yet a cold fire burns beneath the surface, a conviction of the ultimate necessity for man's redemption. In 1918 he wrote:

> Gefährlich versucht die Vision: – Leidenschaft stachelt sie – die erstickt die Stimme, die reden soll, um gehört zu sein. Furchtbar schwingt dieser Kampf zwischen Schrei und Stimme. Im Schrei will es sich aus dem Munde reißen – Aufschrei aus Entsetzen und Zorn! – zur Stimme muß er herabsinken, um wirkend zu werden. Kühle Rede rollt leidenschaftlicher Bewegtheit entgegen – das Heißflüssige muß in Form starr werden! – und härter und kälter die Sprache, je flutendüberflutender Empfindung bedrängt.
>
> Von welcher Art ist die Vision?
> Es gibt nur eine: die von der Erneuerung des Menschen.

> (Dangerously the vision tempts: passion goads it onwards – this stifles the voice that should speak to be heard. Fearful is this fight between cry and voice. It wishes to burst from the mouth as a shriek – a scream of horror and anger! – it must become a voice in order to be effective. Cool speech rolls towards passionate agitation – the molten must become rigid in form! – and the colder and harder the language is, the more turbulent and moving the emotion will be.
>
> What is the nature of this vision?
> There is only one: the Renewal of Man.)

In Kaiser the idea of social reform is only of secondary importance: a Nietzschean self-overcoming, a spiritual regeneration must come first before society can be changed. It is false to refer his plays solely to the conditions prevailing in Germany at the

end of the war, as Kaiser's idealism is universally valid, but a
certain relevance is undeniable. His famous play *Die Bürger von
Calais* (*The Burghers of Calais*) was written in 1913 and published
the following year; it is an argued condemnation of war and
received its first performance in Frankfurt am Main in 1917. The
clash between Duguesclins, Constable of France, who demands
resistance to the English, the salvation of honour and the fight
to the death, and Eustache de Saint-Pierre, who sees that sur-
render and preservation of the work of generations is far more
valuable, has a fascinating dramatic impetus: thesis and argument
are rigidly controlled, and the white-heat of intellectual passion
is compressed and concentrated until an intolerable tension is
achieved. Eustache de Saint-Pierre demands an absolute self-
purification, a dedication to the noblest vision – self-sacrifice
and the preservation of the city with its new harbour. Military
glory, he exclaims, is a worthless idea, and he who longs for it
is as debased as the enemy:

> Wir sahen die Küste, die steil ragt – wir sahen das Meer, das wild
> stürmt – wir suchten den Ruhm Frankreichs nicht. Wir suchten das
> Werk unserer Hände! – Einer kommt, den spornt die Wut. Die Wut
> entzündet die Gier. Mit wütender Gier greift er an – und rafft auf,
> was er auf seinem Wege findet. Er häuft es zu einem Hügel von
> Scherben – höher und höher – und auf seinem äußersten Gipfel
> stellt er sich dar; – lodernd in seinem Fieber – starr in seinem Krampf
> – übrig in der Zerstörung! – Wer ist das? Empfangt ihr von ihm
> das Maß eures Wertes – die Frist eurer Dauer? – den heute die
> Gier anfaßt, die morgen mit ihm verwest?

> (We saw the coast, rising steep – we saw the sea, storming wild – we
> sought not the fame of France. We sought the work of our hands!
> One comes, goaded by rage. Rage kindles greed. With raging greed
> he attacks – and seizes what he finds in his path. He piles it to a heap
> of rubble – higher and higher – and on its highest peak he stands
> himself – burning in his fever – rigid in his convulsion – left in the
> destruction! Who is this? Did you receive from him the measure

of your worth, the length of your duration? – the one whom greed
grips today, which perishes with him tomorrow?)

Seven come forward (this is Kaiser's original alteration to the
traditional account); six are needed to humiliate themselves before
the English king. Eustache de Saint-Pierre knows that they are
not yet ready for the need of self-sacrifice, that they all secretly
desire life and that they all long to draw the lot which will deter-
mine who shall be spared. He ruthlessly admonishes them to
transcend human weakness, and the final scene of Act Two is a
strange fusion of Christian communion and Nietzschean im-
periousness:

> Seid ihr reif – für eure neue Tat? . . . Ihr buhlt um diese Tat – vor
> ihr streift ihr eure Schuhe und Gewänder ab. Sie fordert euch nackt
> und neu. Um sie klirrt kein Streit – schwillt kein Brand – gellt kein
> Schrei. An eurer Brunst und wütenden Begierde entzündet ihr
> sie nicht. Eine klare Flamme ohne Rauch brennt sie – kalt in
> ihrer Hitze – milde in ihrem Blenden. So ragt sie hinaus – so geht
> ihr den Gang – so nimmt sie euch an: – ohne Halt und ohne
> Hast – kühl und hell in euch – ihr froh ohne Rausch – ihr kühn
> ohne Taumel – ihr willig ohne Wut – ihr neuerol Täter der neuen
> Tat!

> (Are you yet ripe – for your new deed? You woo this deed, you take
> off shoe and clothing before it. It demands you naked and new. No
> battle rattles around it, no fire leaps, no cry shrills. Your lust and
> raving gestures do not ignite this deed. It burns as a clear flame without
> smoke – cold in its heat – mild in its gleam. Thus it rears up – thus
> you should go – so it accepts you – without stop or haste – cool and
> clear in you – happy without wild ecstasy, brave without frenzy –
> you who are willing without rage – you new perpetrators of the new
> deed!)

In the final act Eustache de Saint-Pierre commits suicide that he
may go on before the six into death and show the way; his father
brings the body and speaks as a prophet to the waiting citizens:

'Ich komme aus dieser Nacht – und gehe in keine Nacht mehr. Meine Augen sind offen – ich schließe sie nicht mehr. Meine blinden Augen sind gut, um es nicht mehr zu verlieren: – ich habe den neuen Menschen gesehen – in dieser Nacht ist er geboren!' ('I come from night, and go no longer into night. Mine eyes are open, I close them no more. Mine eyes are good, to lose this never: I have seen the new man, he is born in this night!'). The body of his son is carried into the church and laid upon the altar, so that the English king, who has spared the lives of the six because of the birth of a son, and who wishes to offer thanks to God, must kneel before his spiritual conqueror. The final tableau, assisted by the lighting, emphasizes the Christ-like sublimity of the moral victor, showing resurrection and ascension.

Three months later, in the same year, Kaiser's most famous play, *Von morgens bis mitternachts* (*From Morn till Midnight*) was staged in Munich (it was, in fact, his thirtieth play, written in 1912, shortly before *Die Bürger von Calais*). It was this play more than any other that seemed to be the quintessence of German Expressionist theatre, and made Kaiser's name and method famous outside Germany; after the war it was staged in London and New York, and also made into a film by Karlheinz Martin. A nameless bank cashier passes through several stations in a process of self-exploration; he revolts against his meaningless life, steals 60,000 marks and sets off ('bricht auf') in search of frenzied excitement. The concentration is extreme: the opening scene in the bank has a deliberately jerky quality, as though the actors were in fact puppets, and in each 'station' the grotesque element becomes more and more apparent. The action becomes barely causal; the cashier indulges in the pleasures of the flesh in a scene which is very reminiscent of the prostitute scene in Sorge's *Der Bettler*, and with an undeniable sadism exults in the frenzy of a six-day cycle race. Finally, in a Salvation Army Hall, he realizes the worthlessness of money and hurls it amongst the audience, who fight like

wild beasts for it; betrayed by the Girl he shoots himself before a crucifix: his dying words sounding like 'Ecce Homo'. He had hoped to live life to the full, to cast off an inauthentic existence, but was corrupted from the start by his crime; reliance on capitalist gain was not the premise for the overcoming of mechanical, materialist society.

Kaiser does not attempt to create rounded characters of flesh and blood: psychological naturalism was of no interest to him. The characters are stripped to bare essentials, they are frequently abstractions, types who point out the main tenets of the argument. The Salvation Army penitents could well be emanations from the protagonist's mind, as in Strindberg; the symbol of death – the skeleton in the wintry trees, and finally in the wires holding the chandelier – is a warning and a projection of the cashier's dread. The blasts on the trumpet which intersperse his final peroration seem to herald a last judgement. The deliberate unreality of the play, the jerkiness, frenzy, self-laceration and almost flippant awareness of the worthlessness of life were well captured in the film, made in 1920 and presumed lost, until finally discovered in archives in Japan.

After *Die Bürger von Calais* and *Von morgens bis mitternachts* it is the *Gas* trilogy which established Kaiser's reputation. The first part, *Die Koralle* (*The Coral*), was staged in Frankfurt am Main and Munich in 1917; in it Kaiser shows himself to be highly critical of capitalist ruthlessness, for although the Millionaire dominates the play, both his son and his daughter represent a rejection of bourgeois complacency and a criticism of social inequality. The son particularly identifies himself with the oppressed masses and, in Act Three, is on the point of shooting his father before he joins the workers: it is he who will be the hero of *Gas I*. Connected with the idea of the emergence of the New Man is a theme which is common in Kaiser – the exchange of a man's identity to gain a new lease of life: this the Millionaire attempts to

do, assuming the role of his murdered secretary, and living vicariously through his son.

It is, however, the second play of the trilogy, *Gas I*, which made Kaiser a European name. It was performed a few days after the armistice, and, with its idea of the regeneration of society at large, it seemed again, like *Die Bürger von Calais*, to have a meaning especially relevant to the German situation at that time. Gas, the driving force behind all modern machines, is the symbol or essence of the new industrial age. At the factory which produces gas the Millionaire's son rules with a devoted idealism, but he cannot prevent the immense explosion which reduces the factory to rubble. A Strindbergian touch is 'der weiße Herr' who is an embodiment of a premonition of disaster, the white terror which obliterates all. After the catastrophe the Millionaire's son sees the chance for a new life: he will resettle his workers on the land, and restore them to health and joy. Act Four is the brilliant dialectical clash between the Millionaire's son and the Engineer, who represents ruthless technology; the workers are swayed back and forth between the two opposing theses:

INGENIEUR: Helden seid ihr – in Ruß und Schweiß! Helden seid ihr am Hebel – vorm Sichtglas – am Schaltblock! Reglos harrt ihr aus im Treiben der Riemen und mitten im Donner der polternden Kolben! – Und noch das Schwerste stößt in euch kein langes Erschrecken: – die Explosion!

MILLIARDÄRSOHN: Kommt aus der Halle!

. . .

INGENIEUR: Herrscher seid ihr hier – im Werk von allmächtiger Leistung – ihr schafft Gas! . . . Herrscher seid ihr hier – da seid ihr: – Bauern!!

EINE STIMME (*schreit*): Bauern!

ANDERE STIMMEN: Bauern!!

NEUE STIMMEN: Bauern!!!

ALLE MÄNNER UND FRAUEN (*Brandung von Schreien und Fäuste auf*): Bauern!!!!

MILLIARDÄRSOHN (*auf Stufen der Tribüne*): Hört ihr auf mich – oder ihn?

ALLE MÄNNER UND ALLE FRAUEN: Der Ingenieur!!!!

. . .

MILLIARDÄRSOHN: . . . Kommt nun heraus!! Ihr seid Helden – die keinen Versuch unterschlagen! Bis ans Ende des Wegs dringt ihr kühn – kein Schrecken fällt in euren Schritt! – Der Weg ist zu Ende – *ein* Weg ist wieder zu Ende – lobt euren Mut mit neuem Mut: – der Mensch ist da!!!!

. . .

ALLE MÄNNER UND FRAUEN: Der Ingenieur soll uns führen!!!!

INGENIEUR: Kommt aus der Halle!! – ins Werk!! – von Explosion zu Explosion!! – Gas!!

ALLE FRAUEN UND ALLE MÄNNER: Gas!!!!

(ENGINEER: You are heroes – in soot and sweat! You are heroes at the lever, before the gauge, at the gear-switch! Motionless you stand in the whirring of the belts and in the thunder of the crashing pistons! And even the most fearful event causes you no lasting fear – the explosion!

MILLIONAIRE'S SON: Come out of the hall!

. . .

ENGINEER: You are rulers here, in the work of all-powerful production – you make gas! . . . Here you are rulers – there you are – peasants!!

A VOICE (*cries*): Peasants!

OTHER VOICES: Peasants!!

NEW VOICES: Peasants!!!

ALL THE MEN AND WOMEN: Peasants!!!!

MILLIONAIRE'S SON (*on the steps of the tribune*): Do you listen to me – or to him?

ALL THE MEN AND WOMEN: The Engineer!!!!

. . .

MILLIONAIRE'S SON: . . . Come away!! You are heroes, who fear no trial! You carry on without fear to the end of the road – no terror makes you falter in your stride! The road has ended – *one*

E

road has ended again – praise your courage with fresh courage –
Man is there!!!!

. . .

ALL THE MEN AND WOMEN: The engineer shall lead us!!!!
ENGINEER: Come out of the hall – back to work!! – From explosion
to explosion!! – Gas!!
ALL THE MEN AND WOMEN: Gas!!!!)

The mass of workers, unregenerate, pour back into the factory
after the Engineer: the vision of the Millionaire's Son is not
realized. In the final act representatives of big business, as well
as the army, seize the works to ensure the production of gas:
ruthless egotism and mechanization rule triumphant. But the
Millionaire's Son cannot forget his ideal:

MILLIARDÄRSOHN: Sage es mir: wo ist der Mensch? Wann tritt
er auf – und ruft sich mit Namen: – Mensch? . . . Muß er nicht
ankommen – morgen und morgen – und in stündlicher Frist?! –
Bin ich nicht Zeuge für ihn – und für seine Herkunft und Ankunft?
– ist er mir nicht bekannt mit starkem Gesicht?! – Soll ich noch
zweifeln?!!

TOCHTER (*nieder in Knie*): Ich will ihn gebären!

(MILLIONAIRE'S SON: Tell me – where is Man? When will he
appear, and call himself by name: Man? . . . Must he not arrive –
tomorrow, and tomorrow, and in the space of an hour?! Am I
not a witness to him – his origin and advent – is he not known to me
with his face of strength?! Must I still doubt?!!

HIS DAUGHTER (*kneeling*): I shall give him birth!)

There is hope, then, for the future. But *Gas II*, performed two
years later, is a portrayal of apocalyptic doom. The Millionaire's
grandson has remained true to humanitarian ideals: he is now the
Millionaire-Worker. His antagonist is the Engineer, now Chief-
Engineer, who is virtually an automaton: the mechanical regularity
of his movements mirrors the machinery around him, and the
total abstract soullessness of modern technology. Gas is in even
greater demand since the outbreak of war, and the workers are

reduced to machinery themselves: the Millionaire-Worker, how-
ever, suggests that the workers should unite with their fellowmen
on the enemy's side, that a call for peace and mutual love be
radioed across the world. But he is greeted only with silence and
the destructive savagery of the Chief-Engineer, who tells of the
production of *Giftgas* – poison gas which eats away the living
flesh. The clash between Millionaire-Worker and Chief-Engineer
reaches a fearful intensity:

> MILLIADÄR-ARBEITER: Gründet das Reich!!
> GROSSINGENIEUR: Zündet das Giftgas!!!
> ARBEITER: Giftgas!!!!
>
> (MILLIONAIRE-WORKER: Found the new Kingdom!!
> CHIEF-ENGINEER: Set off the Poison Gas!!!
> WORKERS: Poison Gas!!!!)

In a climax of horror the Millionaire-Worker realizes that his
ideal is totally unrealizable, and, in bitterness and disillusionment,
he smashes the glass of poison gas on the floor, whilst the enemy
bombardment starts outside. A Yellow Figure, one of the enemy
soldiers, sees the shattered building, the concrete slabs lying on
top of each other like gravestones, beneath which are lying the
skeletons of those whose flesh the gas has destroyed. He reports
back to his troops, crazed and demented, for he has seen the
Day of Judgement: 'Kehrt die Geschütze gegen euch und vernich-
tet euch – die Toten drängen aus den Gräbern – jüngster Tag –
dies irae – solvet – in favil . . .' (er zerschießt den Rest in den
Mund) . . . ('Turn the guns against yourselves and destroy
yourselves – the dead are bursting from the graves . . . judgement
day – dies irae – solvet – in favil . . . (He shoots the rest in his
mouth, . . .'). The final stage direction explains: 'In the hazy
distance clusters of fire-balls hurtle against each other – clearly
in self-destruction'. In this startling work Kaiser shows what war
means in an age which can produce weapons of mass destruction;

he has seen how the demagogue seizes power over others and how, finally, man can destroy himself in a paroxysm of self-hatred. Man devotes his energies ultimately to suicide: the self-annihilation of civilization is at hand.

What, then, of the New Man? Will the potential in man for goodness and love be realized, or is man bent on destroying the world and himself? A play written between *Gas I* and *Gas II*, *Hölle Weg Erde* (*Hell Way Earth*) describes in almost religious terms a journey made by 'Spazierer' (the 'Walker') out of the hell of modern capitalism to the heaven-on-earth of universal brotherhood: light floods the stage at the end as men struggle towards true communion. But is it achieved? And the question must be asked: is there not in Kaiser a ruthless, almost cruel element, a narcissistic sense of power which contradicts the altruism of the vision of the New Man? One remembers the hectic selfishness of the Bank Cashier in *Von morgens bis mitter-nachts*, the deliberate, almost sadistic prolongation of suffering deemed necessary by Eustache de Saint-Pierre in *Die Bürger von Calais*; there is the violence used in *Hölle Weg Erde* and other plays (*Kanzlist Krehler* and *Zweimal Oliver*) and the hideous carnage of *Gas II*. The obsession of Kaiser with certain themes, the almost monomaniacal dedication of many of his characters, the reduction of men to automata, the abstract stage settings, the steel constructions and harsh lighting reflect a cruelty and bleakness which is not altogether expelled by an ideal which seems frequently Nietzschean rather than Christian. It must, however, be remembered that the plays Kaiser wrote between 1917 and 1923 were created whilst Germany was in the grip of defeat, collapse, revolution and disillusionment; the country was tremulous with hopes for a better future, yet shot through with brutality and civil strife.

Before the end of the fighting in 1918 two further plays appeared on the German stage (albeit in restricted performances) which

showed the senselessness of war and its brutalizing effect on men: Fritz von Unruh's *Ein Geschlecht* (*A Stock*) and Reinhard Goering's *Seeschlacht* (*Naval Battle*). Fritz von Unruh (1885–1970) was a Prussian officer, formerly a page at the Imperial Court, who had devoted himself to literature at the age of twenty-seven, modelling himself upon Heinrich von Kleist. His earlier plays, *Offiziere* and *Prinz Louis Ferdinand* had extolled the Prussian military traditions, and were full of patriotic fervour and panache, but direct experience in the fighting of 1914 had convinced von Unruh of the horror and degradation of modern warfare. His dramatic poem *Vor der Entscheidung* (*Before the Decision*) describes the change of heart, the rejection of Heinrich von Kleist and his hectic and morbid nationalism, and the debt to Shakespeare, the writer who loved mankind in all its forms. Kleist may tempt to death, but von Unruh does not heed him: he recognizes and abominates the life-destroying cult of militarism and glory and turns his back upon his birth, upbringing and traditions. *Ein Geschlecht* was written in 1916: its blank verse is modelled upon that of Kleist and the lofty grandeur of the language looks back to Schiller, but the violence and extremity of the emotions expressed place von Unruh very much within the German Expressionist fold.

The scene is a nocturnal cemetery, where the Mother, the Daughter and the Youngest Son have buried a favourite son who died a hero in battle. Suddenly the two remaining sons are brought to them in chains, one guilty of cowardice, the other of brutal insubordination. This latter is the Eldest Son and he is the protagonist, a figure exemplifying amoral energy and radical nihilism. Brutalized by the war, he turns his violence against the Mother and Daughter, his sexual urges lusting for an incestuous relationship with his sister. Von Unruh sees clearly that nationalism liberates aggressiveness which it cannot ultimately control (the Eldest Son had been found guilty of rape), and yet which it

obtusely expects to keep within limits; frustrated and racked with violent torment the Eldest Son curses the Mother for giving him life which brings death with it. He cannot control his murderous impulses which were formerly approved by the State: his vitalism, perverted, turns to self-destruction, and he jumps from the cemetery wall. The Mother, spiritually transformed, calls upon the mothers of the world to stop the madness of war, and proclaims a message of hope and love. Although she is killed by the Commander, the Youngest Son is inspired by her vision and leads the soldiers to rebellion down on the plains; the dawn proclaims a new day for mankind.

This is a most remarkable play, a concentrated expression of explosive power. It is obviously an anti-war play, in that the Mother seizes the staff of power and calls for a halt to the killing; although she perishes her ideal will ultimately triumph. But the work also touches on the theme of the proximity of lust and violence and also contains a deep conviction of the absurdity of life (the Eldest Son's condemnation of birth which contains death already within it), as well as a proclamation of matriarchal triumph. It is quintessentially expressionistic in that it is an outburst (albeit in traditional verse form) of pent-up, lava-like emotions: it combines an optimistic humanitarian ideal with a shrill, hectic sadism which is only just dispelled.

Reinhard Goering (1887–1936) wrote his play in a Davos sanatorium during convalescence; although not as powerful as *Ein Geschlecht* and more closely linked to a particular situation (the Battle of Jutland) it has a gripping, fatalistic quality at times reminiscent of ancient tragedy. The action takes place in a gunturret of a battleship, dominated by a huge gun: the seven sailors are nameless and, after donning their gasmasks, faceless. The language is clipped and jagged, swelling at times to a rhythmic pathos; memories and visions give way to fervour and a sombre ecstasy:

DER ERSTE MATROSE (*an der Luke*): Skagerrak! Skagerrak! Letzter
Mai! Siegestag! Jammertag! Lebt wohl Heimat, Land, alles, alles . . .
DER ZWEITE MATROSE: Komm mit uns, Bruder! Komm! Lebe!
DER DRITTE MATROSE: Komm mit uns, Bruder! Komm! Siege!
DER VIERTE MATROSE: Komm einfach mit uns sterben, Junge!

(FIRST SAILOR (*at the lookout*): Jutland! Jutland! Last day of May!
Day of Victory! Day of Woe! Farewell Fatherland, home, every-
thing, everything . . .
SECOND SAILOR: Come with us, brother! Come! Live!
THIRD SAILOR: Come with us, brother! Come! Triumph!
FOURTH SAILOR: Come with us, lad, simply – to die . . .)

The problems of obedience and the possibility of mutiny are
touched upon; what meaning has their sacrifice?

STIMME: Vaterland, Vaterland, o lieb Vaterland. Wir sind Schweine,
die auf den Metzger warten. Wir sind Kälber, die abgestochen
werden. Unser Blut färbt die Fische! Vaterland, siehe, sieh, sieh!
Schweine, die gemetzt werden, Kälber, die abgestochen werden!
Herde, die der Blitz zerschmeißt. Der Schlag, der Schlag, wann
kommt er uns? Vaterland, Vaterland, was hast du mit uns noch
vor?

(VOICE: Fatherland, Fatherland, oh dear Fatherland. We are pigs
waiting for the butcher, we are calves waiting to be slaughtered.
Our blood dyes the fishes! Fatherland, look, look, look! Pigs to
be butchered, calves to be slaughtered. A herd, shattered by the
lightning. The blow, the blow, the blow, when will it strike us!
Fatherland, Fatherland! What have you left for us?)

But a death-filled rapture triumphs:

STIMMEN: Vaterland, Vaterland, was noch von uns! Vaterland,
Vaterland, Tod frißt uns wie Reis. Sieh uns hier liegen, Vaterland.
Gib uns Tod, Tod! Tod! Gib uns Tod! Tod!

(VOICES: Fatherland, Fatherland, what more from us! Fatherland,
Fatherland, death eats us like rice. See us lying here, Fatherland.
Give us death, death, death! Give us death, death!)

The final explosion kills all: the fifth sailor, the most rebellious, recognizes before his death that dedication finally conquered the thought of insurrection. But Goering is not simply a 'patriotic' playwright here: he portrays men under stress, going ineluctably to their doom and reacting with expressive intensity to their predicament. His *Scapa Flow*, however, which appeared in the following year, is a much more conventional and less distinguished work.

The collapse of Germany, the establishment of the Weimar Republic, the turmoil of violence unleashed upon the streets during the fighting between extremist factions, the feverish and hectic optimism and the strident call for brotherhood created an atmosphere without parallel anywhere else in Europe. Would the New Man now emerge? Could mankind transcend its baseness and rise to spiritual sublimity? In the famous anthology of many of the younger poets already quoted, *Menschheitsdämmerung* (*The Dawn of Humanity*), which was published in 1920, the editor, Kurt Pinthus, wrote: 'Und immer wieder muß gesagt werden, daß die Qualität dieser Dichtung in ihrer Intensität beruht. Niemals in der Weltdichtung erscholl so laut, zerreißend und aufrüttelnd der Schrei, Sturz und Sehnsucht einer Zeit, wie aus dem wilden Zuge dieser Vorläufer und Märtyrer' ('It must be said, again and again, that the quality of this poetry resides in its intensity. Never before in world poetry was the cry so loud, so piercing and convulsing, this cry, the plunging and yearning of the time, as it was from the wild procession of these precursors and martyrs'). In the same year Karl Bröger, in his collection of poems *Flamme*, greeted the new Utopia, whose advent was inevitable; the novelist Leonhard Frank, in his book *Der Mensch is gut* (*Man is Good*) announced the new era, the epoch of brotherhood and love. But the supreme example of German Expressionist fervour, of the expression of hope for the transfiguration and redemption of man, is Ernst Toller's play *Die Wandlung* (*The*

Transformation), performed in Berlin in 1919 and possibly the greatest product of the German theatre at this time.

Toller (1893–1939) had joined the army in 1914: at the front line he underwent a complete transformation, and suffered a spiritual and physical collapse. In Munich he joined the extreme Left, and was imprisoned for his pacifist views; there, in prison, between 1917 and 1918, he wrote *Die Wandlung*, subtitled *Das Ringen eines Menschen* (*A Man's Struggle*), a station-drama moving on two planes, realistic and symbolic, which demonstrates the conversion of the hero from an unthinking patriot to a fervent revolutionary leader.

A nightmare vision opens the play, where skeletons climb from their graves and roll their heads by numbers: a universal death prevails. The first station shows the hero, Friedrich, in opposition to his parental home (one thinks of Hasenclever here): he longs for release and freedom and joins the army to fight in the colonies. The realistic scenes alternate with dream-like visions which could be interpreted as the workings of his subconscious mind, and are frequently anticipations of what the realistic pictures later bring. The train carrying soldiers to their death precedes his awareness of the futility of war; the ghastly scene of the skeletons crawling from the barbed wire entanglements are a premonition of his own wounding and convalescence. A debt to Büchner, particularly *Woyzeck*, is evident in the scene with the medical Professor and the hideously mutilated patients: this will also be found in Toller's later play *Hinkemann*. After the war Friedrich, as a sculptor, is at work on a colossal statue of Victory, but the sight of two wretched war-invalids overwhelms him; he shatters the statue and, after a mental crisis bordering upon suicide, strides forth to join the masses:

Sonne umwogt mich,
Freiheit durchströmt mich,

Meine Augen schauen den Weg . . . (Schreitet ekstatisch zur Tür
hinaus)

(Sun flows around me,
Freedom suffuses me,
My eyes see the way. . . . He strides ecstatically through the
door)

His task is to move amongst men and inspire them with his ideal
of brotherhood and peace. He sees the wretchedness of slums,
the sufferings of the oppressed, the indifference and cruelty of
the authorities; but there is joy at the birth of a child, even amidst
the squalor of prison. Friedrich attends a political gathering,
and clashes with the Agitator who preaches revolution and
yet has no love in his soul; he foretells the new hope, the new
vision, the spiritual rebirth of men in almost Nietzschean terms:

> Nun öffnet sich, aus Weltenschoß geboren
> Das hochgewölbte Tor der Menschheitskathedrale.
> Die Jugend aller Völker schreitet flammend
> Zum nachtgeahnten Schrein aus leuchtendem Kristall.
> Gewaltig schau ich strahlende Visionen.
> Kein Elend mehr, nicht Krieg, nicht Haß,
> Die Mütter kränzen ihre lichten Knaben
> Zum frohen Spiel und fruchtgeweihtem Tanz.
> Du Jugend schreite, ewig dich gebärend,
> Erstarrtes ewig du zerstörend,
> So schaffe Leben gluterfüllt vom Geist. . . .

(Now opens, born from the womb of the world, the high-arched door
of the cathedral of humanity. The youth of all the nations strides
radiant to the shrine of gleaming crystal which was sensed in the
darkness. Powerfully I see gleaming visions, no more misery, no
more war, no more hatred; mothers crown their shining boys for
the game of joy and the fruitful dance. Youth, stride, eternally
propagating yourself, eternally destroying that which is petrified,
and create, create life passionately filled with spirit. . . .)

The *Zarathustra* imagery intensifies: Friedrich becomes Leader, *Führer*, and, in the symbolic mountain scene, leaves the friend who cannot follow. Finally, on the market place, a message of love is preached which stresses the god-like qualities of man and the need for the realization of man's highest potentialities. The prerequisite for this is revolution, glorious, but bloodless:

FRIEDRICH: Nun, ihr Brüder, rufe ich euch zu: Marschiert! Marschiert am lichten Tag! Nun geht hin zu den Machthabern und kündet ihnen mit brausenden Orgelstimmen, daß ihre Macht ein Truggebilde sei. Geht hin zu den Soldaten, sie sollen ihre Schwerter zu Pflugscharen schmieden. Geht hin zu den Reichen und zeigt ihnen ihr Herz, das ein Schutthaufen ward. Doch seid gütig zu ihnen, denn auch sie sind Arme, Verirrte. Aber zertrümmert die Burgen, zertrümmert lachend die falschen Burgen, gebaut aus Schlacke, aus ausgedörrter Schlacke. Marschiert – marschiert am lichten Tag. Brüder, recket zermarterte Hand/Flammender freudiger Ton!/Schreite durch unser freies Land/Revolution! Revolution!

(FREDERICK: Now, brothers, I call to you: March! March in the brightness of day! Now go to the rulers and announce with the rushing voice of the organ that their power is only a deception. Go to the soldiers, tell them to beat their swords into ploughshares. Go to the rich and show them their hearts, which have become heaps of rubble. But be kind to them, for they too are poor, are lost. But destroy the palaces, laugh while you destroy the false palaces, built of slack, nothing but dried slack. March – march in the brightness of day. Brothers, lift up your broken hands, a flaming, joyful tone! Stride through our free land, Revolution! Revolution!)

The workers join hands and stride forth with Friedrich, joining in the chorus with him; a revolution, political and spiritual, is greeted with an almost religious ecstasy, for it is the God in Man that must be released for the New Millennium to dawn.

This play represents a supreme example of what may be called

expressionist political activism: the revolt and aggressive egotism of the writers of the pre-war years have been channelled into an overtly political direction. But the idealism and spiritual foundation of Toller's political engagement was of such an intensity that disillusionment with the actual historical events around him was perhaps inevitable. The soviet republic set up in Munich in the early weeks of 1919 seemed to Toller the promise of a new world, but its ruthless suppression put an end to the Utopian hopes. And not only the Right-wing troops, but the Communists themselves, before Toller's eyes, committed acts of outrage. Poets and writers such as Johannes Becher, Leonhard Frank and Ludwig Rubiner embraced Communism: Toller could not reconcile the violence and brutality of the Communists with their pacifist ideals. His next play, *Masse Mensch* (*Masses Man*), written in 1919 and performed in 1921, is the working out of a conflict between the intellectual and the mob who are not yet ripe for his vision: the situation is obviously Toller's own. His further imprisonment, lasting five years, forced him to take stock of his situation and that of his country, and the whole problem of political activity; his play *Hinkemann*, like *Woyzeck*, shows the hard core of suffering at the heart of existence which no social amelioration can improve. The hero of *Hinkemann*, emasculated during the war, returns home to humiliation and degradation; reduced to earning his living by eating live mice, he sees his wife seduced and hears himself ridiculed. In one section reality is transcended and the contemporary world is shown in a sequence of nightmare pictures which are reminiscent of the newspaper-reading scene of *Der Bettler*; Hinkemann, deranged, hangs himself after the suicide of his wife. The later play, *Hoppla, wir leben* (*Hoppla*), written in 1927, again contains Toller's bitter awareness of the futility of political activity: the hero, closely modelled on Toller himself, sees the fading of the old ideals and the re-emergence of reactionary forces in Germany, and Erwin Piscator's

influence is seen in the production in the use of film-shots and documentary elucidation of recent history. The suicide of the hero seems a sombre anticipation of Toller's own in 1939.

It was claimed in Chapter 3 that the German Expressionists were first and foremost poets and dramatists, and that the discursive prose form lacked the potentiality for immediate, ecstatic expression. Novelists such as Heinrich Mann could, however, and frequently did share the expressionist attack against established authority. His essay of 1910, *Geist und Tat* (*The Spirit and the Deed*), was a call for a united stand by the writers against the threat of militarism and anti-intellectualism in Germany, and his well known novel *Der Untertan* (*Man of Straw*) bitterly attacked all that Dietrich Hessling stood for. Heinrich Mann's attitude to the young writers who welcomed the new way of writing was ambiguous: he feared the irrational elements of German Expressionism yet prided himself on being, with Frank Wedekind and Carl Sternheim, one of the 'precursors and teachers of the younger generation of writers'. He stressed the great social task of the novel form and condemned self-indulgence in the arts, yet his novel *Der Kopf* (*The Head*) of 1925 with its use of slang, its dislocation of syntax and extreme concentration of language seems to be more 'modern' than he would admit. The novella *Kobes* (1923) also had a strange jerkiness and reduction to essentials characteristic of Georg Kaiser. It is probably in Heinrich Mann's plays, however, that the modernist techniques are most apparent: *Brabach* (1916) is very reminiscent of *Von morgens bis mitternachts*, and *Das gastliche Haus* (*The House of Hospitality*) of 1925 is not far removed from the world of Carl Sternheim.

Another novelist worthy of mention in this context is Alfred Döblin (1878–1957) whose best-known novel, written in 1929, is *Berlin Alexanderplatz*. The epic montage effect of his work is similar to that used in Joyce's *Ulysses*; the theme of the individual

and the great city resembles also that of Dos Passos's *Manhattan Transfer*. The novel starts from the real, yet moves towards the surrealistic; its theatrical qualities tend to destroy the traditional novel form, and the grotesque elements overlap with the German Expressionist predilection for the bizarre. Döblin's *Berge Meere und Giganten (Mountains, Seas, Monsters)* of 1924, with its almost science-fiction play of the imagination and its asyntactical accumulation of dynamic verbs, is a bold fusion of futurism, expressionism and surrealism; in *Wadẓaks Kampf mit der Dampf-urbine (Wadẓaks Struggle against the Steam-Turbine)* of 1918 the theme of protest and the extreme tension of language betray a definite expressionist tendency. It would seem appropriate to claim that a novelist is an 'expressionist' if he was critical of society and pushed language to an extreme tension in an attempt to convey his convictions the more readily: as regards the use of expressionist techniques, Hermann Hesse's *Der Steppenwolf* of 1927 could perhaps be mentioned, particularly the so-called 'Magic Theatre' section, where the hero comes face to face with certain aspects of his own personality which have split off into independent life; but Hesse's work is essentially derivative and lacks the full force of expressive originality.

It is customary to equate German Expressionism with left-wing political movements, particularly in the early twenties: many of the writers did, as has been pointed out, turn to Communism, and this was, after all, one of the reasons why the Nazis banned the movement (another reason was the considerable Jewish element in it). But it should also be remembered that the desire for a new society, a new goal, a New Man also overlaps with the National Socialist programme. The emphasis on vitalism, on the irrational and the visionary, is also found in fascism: the play-wrights Arnolt Bronnen and Hanns Johst, and the poet Gottfried Benn (albeit briefly) embraced the Nazi cause. Goebbels himself

wrote a novel *Michael* which has certain expressionist features: his support of the painter Emil Nolde later caused the party certain embarrassment. What is certain is that the atmosphere of febrile fervour, of hysteria and intoxication which characterized the work of so many German Expressionists betrays a restlessness and a tendency to the extreme which cannot be considered healthy. (On the other hand, Kafka's contention, *à propos* a discussion on Hasenclever's *Der Sohn*, that the father–son conflict should be treated as a comedy as Synge does it in *The Playboy of the Western World* comes like a breath of sanity; his views on Ehrenstein and Becher, as reported in the *Conversations with Janouch*, are similarly pertinent and down to earth.) Ronald Gray (in *The German Tradition in Literature 1871–1945*, Cambridge, 1965) describes the situation very well in the following passage:

Few writers of any nation can have been so intimately concerned with the situation of the day as those of Germany at this time. Yet there is a disturbing quality about their plays, something melodramatic about the ghastlinesses they portray, and an excess of emotional language. Skeletons go on parade as soldiers and roll skulls by numbers; a severed head in a sack converses with its former owner; a woman bleats her Dionysiac love to a billy-goat; a father horsewhips his son, a son chases lustfully round the table after his mother, a society is formed for the Brutalization of the Ego. A man earns his living by eating live mice; a crowd of spectators exults pitilessly over the exhausted riders in a seven-day cycle race; the shades of Shakespeare and Kleist stalk over the battlefields; the German navy sinks in ecstatic and apocalyptic splendour in Scapa Flow. Too often there emerges from such scenes a radiant sun flooding the landscape with light while bands of pilgrims rejoice in a new-found freedom or some similar note of boundless optimism is struck. A crowd of dancers press orgiastically together, groaning their self-discovered divinity – this time, no doubt, as objects of satire, although one may ask what kind of society called for such satirizing. A bank-cashier stands with arms outstretched in front of a crucifix, his dying gasps accidentally suggesting the words

'Ecce Homo'. An atmosphere of painful contrivance is felt every-where, a hysterical abandonment to the wildest hopes and the unlikeliest despair . . . (pp. 48–9).

The same may equally be said of the lyric, with its distracted, feverish, millennial hopes, and even more so of the new art-form of the cinema, with its emphasis on distortion, automata, cruelty and vampirism. The classic here, of course, is *The Cabinet of Dr. Caligari*, made in 1919 with its première in February 1920; the bizarre atmosphere is brilliantly caught in Walter Reimann's sets, with their distortion and tortuous, labyrinthine quality, through which the somnambulist (Conrad Veidt) and the maniac doctor (Werner Krauss) move in a nightmare progression. Two versions of *Der Golem* (1912 and 1916) captured the mysterious atmosphere of Prague, the twisting streets and ghostly shadows; in 1920 the famous *Von morgens bis mitternachts* was filmed, and three years later Robert Wiene, responsible for *Caligari*, made his *Raskolnikoff*. Fritz Lang's famous *Metropolis* (1926) owes an obvious debt to the *Gas* trilogy, particularly in the portrayal of the clash between father and son, and the fearful 'Moloch' scene. The interest taken by many writers in the cinema is seen in the *Kinobuch* edited by Kurt Pinthus which contained film scenarios by Hasenclever, Else Lasker-Schüler (at one time Herwarth Walden's wife), Max Brod (friend of Franz Kafka) and the minor Expressionists Albert Ehrenstein, Ludwig Rubiner and Paul Zech. The weirdness and atmosphere of menace and dread conveyed by so many of the German Expressionist films led one critic, Siegfried Kracauer, to claim that, after 1933, Germany carried out what had been anticipated by her cinema from the beginning.

German Expressionism, however, was too modernist, too anti-authoritarian and enjoyed too many links with the international world to survive under a dictatorship: the works of nearly all the writers mentioned in this section were either burnt or banned,

and the notorious exhibition of 'Entartete Kunst' ('Degenerate Art') held in Munich in 1937 branded the painters with ignominy. It is ironic that the Nazi party, in stamping out German Expressionism, should have been bent on destroying what was probably Germany's most original contribution to the arts since the Middle Ages. Yet it must also be realized that almost ten years before the Nazis came to power the movement was waning and losing its force. The rhetoric and bombast had overstepped themselves: a reaction was inevitable. The middle years of the Weimar Republic had marked a return to a more normal way of life in Germany, without the hectic fever of the earlier years: a new sobriety, a nonchalance even began to supersede the hyperbolic visions. Brecht's *Baal*, although containing certain expressionist elements, is an attempt to write a better play than Hanns Johst's *Der Einsame* (*The Lonely One*); Brecht's second play, *Trommeln in der Nacht* (*Drums in the Night*) deflates the whole idea of revolutionary fervour. His alienation techniques, together with the functionalism of the Bauhaus, and the new classicism in music demonstrate a desire for a more intellectual, sparser, less emotional attitude in the arts. But before attempting to describe the possible demise of expressionist tendencies we shall look at Europe as a whole to see if a similar pattern is observable outside Germany.

5
Wider Horizons: Europe and North America

It is frequently argued that expressionism is as typically German a phenomenon as impressionism is a French one: the formlessness and turbulence of the movement, as well as its intensity and abstraction, are looked upon as being somehow *urdeutsch*, and the origins are traced back to the *Sturm und Drang* of the eighteenth century, to Baroque dynamism and even Gothic distortion. But it can also be argued that Expressionism is simply the name given to that form which modernism took in Germany (see Patrick Bridgwater's introduction to *Twentieth Century German Verse*), and if this is the case then the expressionist debt to France is considerable, for it was in that country that virtually all the new movements in the arts originated.

Expressionism has been looked upon as a reaction against naturalism and symbolism, literary movements exemplified above all by Zola and Mallarmé. But upon closer consideration it would seem that Zola's famous dictum concerning the work of art, that it should be 'un coin de la nature vu à travers un tempérament' admits the necessity for subjectivity, a *tempérament*, which is not far removed from the expressionist position. Likewise the naturalist *Sekundenstil* and the pointilliste techniques of the impressionists both tend towards a dissolution of conventionally understood reality into fragments, which is surely an approximation to distortion and abstraction. On a more obvious level the political-activist concerns of Zola would link his name with those of certain German Expressionist writers whilst, at the other

extreme, the emphasis on abstraction, inwardness and the power-
ful radiance of the symbol as advocated by Mallarmé would also
be meaningful for many expressionist writers. The name of
Bergson was also mentioned amongst the precursors of the
movement, but the French writer who comes very close to expres-
sionist vitalism, and whose poetry, in fact, predates much of the
German writing, is Arthur Rimbaud (1854–1891).

French poetry, of course, had begun to be 'modern' with
Baudelaire: poets such as Eliot and Pound in England found in
him, and Laforgue and Rimbaud, the modernity for which they
were looking. There were no sweeping innovations in twentieth-
century French poetry to compare with what Eliot and Pound
were doing between 1914 and 1920 in England because it had
been done decades before: as early as 1870 Rimbaud had proclaimed
that 'il faut être absolument moderne'. And Rimbaud particularly
was the guiding spirit of many of the young German writers at
the beginning of the century, especially after the K. L. Ammer
translations of his poetry in 1907: 'Le bâteau ivre' became the
most famous poem in the French language. Theodor Däubler
translated it masterfully; Paul Zech wrote a stage-version (pro-
duced by Piscator in 1927); Bert Brecht appropriated much of its
imagery in *Baal*; Oskar Loerke's 'Pansmusik' is full of echoes of
Rimbaud. In November 1910 George Heym described in his diary
how Rimbaud was a seer, a prophet, a god, and the poetry of
Georg Trakl bears witness to the presence of this deity. The
splendid rhetoric of the poem, the virtuosity of the seventeen-year-
old author, the masterful coinage of imagery, the use of rare
words and neologisms – above all the sense of revolt, the plunge
into the elements, the drunken boat as a symbol for total liberation:
these features were to make a great impact on German Expres-
sionism. 'Les haleurs' (the towmen) – order and authority – have
been destroyed: chaos is unleashed again. The tempestuous
violence and the yearning for joyous pantheistic union with the

sea carry the poem forward in coruscating images; the drowned corpse forestalls the predilection for the Ophelia theme in Heym, Benn and Brecht. The vitalism in Rimbaud is so intense that it is almost akin to a deathwish; this ambiguity which lies at the very heart of Nietzschean affirmation is an important element in German Expressionism also.

The fusion of mysticism and primitivism in Rimbaud, as well as his insistence that the poet should be *voyant* (in the famous letter to Izambard) have obvious parallels with the work and aspirations of many of the young German writers under scrutiny. A further French poet whose impact was not as great as Rimbaud's but who nevertheless has much in common with the Germans is Guillaume Apollinaire (1880–1918), hailed by many in France as 'le prince de l'esprit moderne'. In 1912 Apollinaire visited Herwarth Walden in Berlin and lectured to the *Sturm* circle: in the following year he published 'Alcools', together with his *L'anti-tradition futuriste*, which was based on a consideration of the work of the Italian futurist Severini. Apollinaire's self-perpetuating imagery reminds the reader of Stadler, and his use of metaphor can be compared to that of Trakl. With 'Qu'est-ce qui se passe', however, he seems closer to Lichtenstein, whereas other works (the play *Les mamelles de Tirésias*) may be called surrealist rather than expressionist, containing echoes of Alfred Jarry, a writer whom Apollinaire held in high esteem. Iwan Goll's *Paris brennt* (*Paris is Burning*) of 1921 owes much to the cubist montage-effect of Apollinaire, whose poems frequently dissolve into images naturally suited to the cinema, as do those of Blaise Cendrars (1887–1961), the title poem of whose *Prose du Transsibérien* (1913) is highly reminiscent of Gottfried Benn and brings to mind George Grosz's illustrations. There is much in Apollinaire that looks back to Laforgue and Baudelaire, but the modernity tinged with fantasy, the strange juxtapositions, discontinuity and simultaneity, also the off-hand flippancy, smack

very much of the second decade of this century; 'La chanson du mal-aimé' and 'Vitam impendere amori' are good examples here. 'La jolie rousse', however, together with other war poems of 'Calligrammes', is a moving document of the poet who, 'Ayant vu la guerre dans l'Artillerie et l'Infanterie/Blessé à la tête trépané sous le chloroforme/Ayant perdu ses meilleurs amis dans l'effroyable lutte' ('Having seen the war in the artillery and the infantry, wounded in the head, trepanned under chloroform, having lost his best friends in the terrible struggle') emerges only to suffer the attacks of traditionalists and narrow-minded critics, but who nevertheless knows that his way is right. The poem ends on a note of sadness, almost a crucifixion: 'Mais riez, riez de moi/ Hommes de partout surtout gens d'ici/car il y a tant de choses que je n'ose vous dire/ Tant de choses que vous ne me laisseriez pas dire/Ayez pitié de moi' ('But laugh, laugh at me, men everywhere, especially men from here, for there are so many things that I dare not tell you, so many things that you would not let me say. Have pity on me').

Apollinaire died in 1918 of wounds sustained to the brain. Perhaps France's most outstanding war loss, however, was Charles Péguy (1873–1914). Péguy belonged to that generation of poets who emerged in France after the symbolists, naturalists and the decadents of the 1890s, one of that generation inspired by Whitman, Bergson and Nietzsche. A pantheistic vitalism is evident in his poetry; his atavism, mythomania and anti-rationalism make him seem more German than French. Stadler greatly admired his work and translated his poetry into German; it was rumoured that the two poets met and exchanged greetings in the trenches. The periodical *Die Aktion* paid tribute to Péguy after the news of his death in the October number of 1914 and had a drawing of Péguy by Egon Schiele on the cover (see Willett, p. 106), and in 1915 brought out a special French number in memory of him. There is no fierce urgency in Péguy, but a slow descent

into the chthonic, a desire, almost, for obliteration in the eternal rhythms of nature. This longing to lose individuality, to submerge into the primitive and the Dionysian, a yearning ultimately for death (as seen in the constant refrain from 'Les sept contre Paris' – 'Heureux ceux qui sont morts . . .' – 'happy are those who are dead') was seen in Kaiser's *Die Koralle*, also in certain of the poems of Gottfried Benn, and indeed in some aspects of D. H. Lawrence; it is interesting also that Valéry, that most cerebral of poets, should also extol the sea, the flux and turmoil of creative forces, the watery abyss, rather than the solipsism of the sparkling mirror in 'Le cimetière marin'.

'From France', writes Walter Sokel, 'came to the Expressionists not only the vitalist modernism of Rimbaud and Apollinaire, the abstractionist modernism of Mallarmé and the political-activist inspiration of Voltaire, Hugo and Zola, but also the Christian poetry of Charles Péguy and the Christian modernism of Paul Claudel' (p. 147). But if 'French Expressionism' seems a highly dubious literary concept it is because the movement known as surrealism rapidly became a most potent force in French literature. Although surrealism shared with expressionism the need for liberation and regeneration, its roots may be found in a different soil, in Jarry and Freud and in such nineteenth-century precursors as Nerval. Such a claim as 'Le surréalisme n'est pas une forme poétique. Il est un cri de l'esprit qui retourne vers lui-même et est bien décidé à broyer désespérément ses entraves' ('Surrealism is not a poetic form. It is a cry of the spirit which turns in upon itself and is determined to shatter its fetters in despair') sounds as though it might have been taken from an expressionist manifesto, but the emphasis on dreams, irrationality and the subconscious advocated by André Breton and others in the *Manifeste du Surréalisme* of 1924 smacks more of neoromanticism and Dada (Tristan Tzara had collaborated briefly with Breton): political activism and pantheistic yearning seem alien here. But it is perhaps

inevitable that the German cultural scene should develop in a way radically different from that of France: the collapse of 1918 and the febrile years of the Weimar Republic described in Chapter 4 fashioned a literary mode of expression unique in Europe.

And what of the links between German and Anglo-American poetry immediately preceding, during, and after the war? It has been traditional to regard English literature preceding the war as an anachronism when compared with the modernist experiments elsewhere; Georgian poetry is generally decried as being un-adventurous and remote from fascinating dislocation. But it is, of course, Eliot and Pound who approach, in certain poems and other writing, a position not entirely alien to the German cultural scene. The emergence of autotelic image and absolute metaphor is, as was mentioned in Chapter 2, a modern tendency shared by German and Anglo-American poetry alike; Eliot's early poems 'Preludes' and 'Rhapsody on a Windy Night', and particularly his 'Sweeney Agonistes' would in all probability have qualified for the label of 'expressionist' had they been written in German (see Willett, p. 171). It is also interesting to remember Eliot's kinship with Gottfried Benn, and the debt to that poet which Eliot later acknowledged in the 'Three Voices of Poetry' (one also remem-bers the theme of retrogression touched upon in 'Prufrock' and evident in Benn and elsewhere). As regards other parallels, a similarity could be found between Joyce's polyglot word-coinages and the experiments of August Stramm, who might also be said to have anticipated the famous 'Stein-stutter' (the phrase is Wyndham Lewis's); J. D. Beresford's *Revolution* (1921) seems an English version of Kaiser's *Gas*, and Stephen Spender's poem 'The Express' (where the train, roaring 'further than Edinburgh or Rome/Beyond the crest of the world . . ./Ah, like a comet through flame . . .') a successor to the Stadler poem discussed in Chapter 3: his 'The Landscape near an Aerodrome', with its oblique, even hysterical description and sense of distortion, seems almost to echo

Georg Heym. But the most remarkable similarity between the German and the English literary scene is to be found in the short-lived movement known as vorticism, centred upon Wyndham Lewis's *Blast* and associated with such names as Ezra Pound, Gaudier-Brzeska, David Bomberg, Jacob Epstein and T. E. Hulme: for a few brief months it seemed as though 'English Expressionism' could be a valid term.

On 20 July 1914 the first edition of *Blast*, the 'puce monster' appeared, with a direct appeal to individualism, energy and creative vision; a few days before the vorticist group had exhibited to-gether at the Doré Gallery in Bond Street, their talents directed against romanticism, cubism and also futurism. At the 1914 exhibition Bomberg had announced: 'I completely abandon *Naturalism* and tradition. I am searching for an intenser expression.' In *Blast I* Wyndham Lewis proclaimed: 'Blast proclaims an art of Individuals . . . The Artist of the modern movement is a savage . . . Shakespeare reflects in his imagination a mysticism, madness and delicacy peculiar to the North. . . . Any great Northern Art will partake of this insidious and volcanic chaos . . .' (see sections III and IV. All references to *Blast* are from the Kraus reprint). The first edition included poems by Pound, also Lewis's dramatic fragment 'Enemy of the Stars'; a discussion of Kandinsky's *Über das Geistige in der Kunst* explains: 'Herr Kandinsky . . . writes of art – not in its relation to the drawing-room or the modern exhibition, but in its relation to the universe and the soul of man. Every artist, as a creator, has to express himself . . .' (p. 119). Lewis attempts to describe the movement in the arts towards abstraction, energy and primitivism, and finally arrives at the concept of the vortex:

As 'Futurist', in England, does not mean anything more than a painter, either a little, or every much, occupying himself with questions of a renovation of art, and showing a tendency to rebellion against the domination of the Past, it is not necessary to correct it . . .

If Kandinsky had found a better word than 'Expressionist' he might have supplied a useful alternative. Futurism, as preached by Marinetti, is largely Impressionism up-to-date. To this is added his Automobilism and Nietzsche stunt ... Our Vortex is not afraid of the Past: it has forgotten it's (sic) existence. The new Vortex plunges to the heart of the Present ... Our Vortex rushes out like an angry dog at your Impressionistic fuss. Our Vortex is white and abstract with its red-hot swiftness.

> (See the sections 'The Melodrama of Modernity' and
> 'Our Vortex', pp. 143–9.)

Lewis does not like the term 'expressionism' (he assumed that Kandinsky had coined the word), neither does he approve of Marinetti's 'automobilism'. But his emphasis on the mysticism and madness of the North, and on the need for self-expression, together with the attack against impressionism and naturalism, puts him very much in the vanguard of the new cultural movement. The first number of *Blast* closed with Pound's views on the primacy of the image in poetry (containing the famous definition: 'An image is that which presents an intellectual and emotional complex in an instant of time'), and a contribution by Gaudier-Brzeska with the memorable statement: 'Will and consciousness are our VORTEX' (p. 158).

But the war destroyed those energies which might have created a new movement in England: by 1915 T. E. Hulme and Gaudier-Brzeska were killed: the second and last issue of *Blast* contained an announcement of the latter's death. It seemed as though the force and dynamism of the 1914 number of the journal were spent; the 1915 *Blast* contained little that was new, but it is interesting that Wyndham Lewis considered the expressionists 'ethereal, lyrical and cloud-like' (p. 40), and talks of their 'Blavatskyish soul'. The two Eliot poems 'Preludes' and 'Rhapsody on a Windy Night' were also published in this number. Yet although *Blast* did not survive, Ezra Pound published, in

1916, his *Gaudier-Brzeska: A Memoir* which contained the import-
ant discussion on imagism and also the statement: 'In the eighties
there were symbolists opposed to impressionists, now you have
vorticism, which is, roughly speaking, expressionism, neo-cubism
and imagism all gathered together in one camp and futurism in the
other' (p. 104). The famous description of the image as VORTEX
(quoted in section 2) is also found here.

Pound equates expressionism with 'neo-cubism' and imagism:
his insistence on the clarity of the image, however, and his hatred
of abstractions (see his *Don'ts for Imagists* of 1913) would of
necessity have made him reject out of hand the turgid bombast and
nebulous effusions of much of the German work discussed in
Chapter 4. The problem of tradition, with which he and Eliot were
much concerned after the war, would have led him increasingly
further from the German literary scene of the early twenties. But a
man who lived in the heart of Europe even during the war, and
who was keenly aware of the new developments was James Joyce,
who arrived in Zurich in June 1915 and on parts of whose work an
expressionist influence is undeniable. He met René Schickele
(1883–1940), the Alsatian writer who was editor for six years of the
journal *Die weißen Blätter*, and who wished Joyce to translate his
play *Hans im Schnakenloch*; he attended performances of plays by
Wedekind, including *Franziska* (he was much interested in
Wedekind and his library included the latter's *Die Zensur*); he also
saw Büchner's *Dantons Tod* and Strindberg's *Dance of Death*
performed by Max Reinhardt's theatre. But it is above all the
'Nighttown' episode of *Ulysses* which justifies the reference
to Joyce in this study, for here his prose assumed a degree
of expressiveness and intensity unequalled elsewhere in the
novel.

Walter Sokel writes: 'Joyce . . . abandons the verbalizing stream
of consciousness for a symbolizing technique close to Expression-
ism' (p. 44). He sees that Joyce lets Bloom's and Stephen's sub-

conscious fears and desires appear as apparitions and hallucinations much as Strindberg had done in *To Damascus*: a *dramatic* visualization is very much in evidence here. In the Nighttown episode there are sections which might almost be part of an expressionist drama (and 'Nighttown' has, in fact, been dramatized): the hallucinatory scenes project the inner preoccupations and tensions of the two men. The nightmarish and the grotesque elements of 'Nighttown' are also worthy of the German cinema of the twenties, which captured, as was described in Chapter 4, the sinister and disturbing aspects of life. Only a few years separate 'Nighttown' and *Caligari*, and the opening of 'Nighttown' might almost be taken from this film: 'The Mabbot street entrance of nighttown, before which stretches an uncobbled tramsiding set with skeleton tracks, red and green will-o'-the-wisps and danger signals. Rows of flimsy houses with gaping doors . . . A deafmute idiot with goggle eyes, his shapeless mouth dribbling, jerks past, shaken in St. Vitus' dance. . . .' Such a scene is an appropriate setting for the dredgings from the deepest recesses of Bloom's mind particularly: his feelings of inadequacy and passivity being externalized in remarkably vivid forms and possibly showing the influence of Joyce's study of Sacher-Masoch. The father-son relationship, a central problem in German Expressionism (see Chapter 3) also figures prominently in *Ulysses*.

The tendency to split off and personify inner states of soul is indeed reminiscent of Strindberg (although it is diverting to read of Joyce's rejection of that dramatist: 'No drama behind the hysterical raving!'); it is, however, the German Expressionist playwrights who came into their own in England and America after the defeat of 1918. A most important intermediary between the German and the English theatre at this time was Ashley Dukes, who, as a German-speaking officer stationed near Cologne, was in the exceptionally privileged position of being able to see all the new experiments on the German stage. He was immensely

impressed by Reinhard Sorge's *Der Bettler*, and describes the play in his reminiscences:

> It was the first expressionist drama, and perhaps the best because it never left the plane of poetry. The subject was modern yet timeless, just one of those German domestic dramas that in prose can be so boring; the verse irregular and strong, seldom lyrical, always dramatic. The staging showed an understanding of the expressionist mind; across the proscenium hung a fine gauze, that now familiar device for preventing the diffusion of light on a subdivided scene. Symbolic arrangements of pieces of furniture and a stove, café seats on a raised terrace, a high window and the shrubs of a garden, formed the sub-division. The lighting moved from one part of this scene to another, leaving all the unlighted part invisible.

(See the article by J. M. Ritchie in *Affinities*, 1971, ed. R. W. Last, p. 99). But the revelation came later in Cologne when Ashley Dukes saw *Von morgens bis mitternachts*, and on his return to England he was determined to translate the play and introduce German theatrical Expressionism into the English theatre.

In 1922 he saw Reinhardt's production of Toller's *Maschinenstürmer* (*The Machine-wreckers*) in Berlin, and arranged a meeting with Toller in prison at Niederschönenfeld to discuss translation. But it was, as J. M. Ritchie has stressed (*Affinities*, p. 103), his version of *From Morn till Midnight* which played a vital role in the little theatre movement in England, particularly the Stage Society and the Gate Theatre: it was at the latter that the famous production with Claude Rains as the Cashier took place in 1925. Financial stringency meant a toning-down of the original Kaiser play, and the element of the grotesque is much less in evidence, but here at last was a chance for the soporific English theatre to see one of the finest examples of Kaiser's craftsmanship. It was, however, in America that the impact made by German Expressionist theatre was most strongly felt, and certain plays of Eugene O'Neill seem to be deeply indebted to it. Although O'Neill had written *The*

Hairy Ape and *The Emperor Jones* before any German Expressionist play had been seen in New York, he had certainly read Kaiser's *Von morgens bis mitternachts* before the 1922 New York production of the Ashley Dukes version. He had also seen *Caligari* in 1921, and the distorted settings reflecting the deranged mind of the protagonist, together with the juxtaposed areas of light and darkness had made a deep impression on him.

O'Neill's remarks to Tennessee Williams on Strindberg demonstrate his admiration for the Swedish writer, but it is interesting that he tended to deny any stimuli from the Germans. 'The point is that *The Hairy Ape* is a direct descendant of *Jones*, written long before I had ever heard of Expressionism, and its form needs no explanation but this' (quoted in B. H. Clark's *Eugene O'Neill*, New York, Dover, 1947, p. 83). *The Emperor Jones* does seem closer to Strindberg in that the distortion is motivated by the character's state of mind, and the 'little formless fears' are externalized as phantom realities, but this tendency is also observable in the case of the Salvation Army penitents in *Von morgens bis mitternachts*. *The Hairy Ape* would seem to stand between *The Emperor Jones* and the plays of Toller and Kaiser in that there is a mixture of realism and stylized elements (O'Neill himself explained that it ran 'the whole gamut from extreme naturalism to extreme expressionism – with more of the latter than the former'). The chorus of stokers, the stylized sets and lighting are certainly reminiscent of Kaiser's *Die Koralle*, as is the descent of Mildred to the nether realm. The Fifth Avenue scene, with the use of automata, has a jerky unreality akin to the films of the twenties. It is also obvious that O'Neill wished to stress the anti-naturalistic aspects of *The Hairy Ape* in the stage directions, where he talks of 'the eight sets, which must be in the Expressionistic method' (see A. and B. Gelb's *O'Neill*, New York, 1962, p. 492), but it is *The Great God Brown* which contains the most expressionistic features of all.

O'Neill's comments on the use of masks are very similar to those of Iwan Goll (see the latter's preface to *Die Unsterblichen* (*The Immortal Ones*)); O'Neill saw how an essential, inner reality may be made more accessible by deliberate distortion and *unreality*. The mask, stylization and ecstatic stammering convey essences far more readily than any attempt at naturalism: the disconnected yet highly suggestive outbursts of Dion in *The Great God Brown* seem to stem directly from German Expressionism: 'I love, you love, we love! ... Come! Rest! Relax! Let go your clutch on the world! Dim and dimmer! Fading out in the past behind! Gone! Death! Now! Be born! Awake! Live! Dissolve into dew – into silence – into night – into earth – into space – into peace – into meaning – into joy – into God – into the Great God Pan!' The deliberately unrealistic, declamatory speech reminds the reader of O'Neill's confession that '*Thus Spake Zarathustra* had influenced him more than any other book he had ever read' (see the Gelbs, p. 121); it can be safely claimed that O'Neill's projecting of the states of soul of his characters through distorted settings, masks, and unrealistic, highly expressive speech does suggest a close affinity with German Expressionism: likewise Brown's assumption of his friend's identity after death in the hope of acquiring his talents and success does seem to stem directly from Kaiser's *Die Koralle* again.

The New York stage of the early twenties was aware of German Expressionism as a theatrical force and emulated many of its characteristics. Short scenes took the place of longer ones, the dialogue became staccato, symbolic characters replaced naturalistic ones; scenes became starkly abstract, lighting was used to create an atmosphere of unreality and choral effects were used together with allegorical group chanting. Elmer Rice's *The Adding Machine* (1923) owes an obvious debt to Kaiser with its seven 'stations', its hero closely modelled on Kaiser's Cashier ('Mr. Zero') and its settings of whirling turntables, its walls decorated with numbers and an adding-machine over which men crawl. The adventurous

Theatre Guild had as its first production of the 1922–23 season Karel Čapek's *R.U.R.*, which certainly seemed in keeping with expressionist tendencies with its bizarre and symbolical drama of man and machine; in 1923–24 Strindberg's *Ghost Sonata* was performed and, in April 1924, Toller's *Masse Mensch*, which, however, was far from a success. In 1924–25 Wedekind's *Erdgeist* appeared and a most ambitious attempt at Hasenclever's metaphysical drama *Jenseits (Beyond)*, a truly subjective experience, a passionate, staccato interchange between two symbolic characters, surrounded by hallucinatory effects (dissolving walls, trees growing into windows and looming shadows) and involved in a mystical, nebulous presentation of life and death. This was the most extreme of the German Expressionist plays performed in America: after this it was Franz Werfel who became famous in New York, with productions of his *Bocksgesang (Goat Song)* and *Spiegelmensch (Mirror-man)*, from which O'Neill may have learned more than he cared to admit: *The Great God Brown*, in its treatment of the two central characters William Brown and Dion Anthony, shows striking parallels with both the Werfel plays. In passing it might also be claimed that John Dos Passos's play *The Moon is a Gong* (staged in the 1925–26 season), in which the mourners do a Charleston around the corpse, is highly reminiscent of the Stockbroker's foxtrot around the stock-exchange in Toller's *Masse Mensch*: the dead from the train wreck remind one of the opening scene of *Die Wandlung*, while the grotesquely stylized houses seem to come directly from *Caligari*.

If it seems that the Americans were more open to German Expressionist theatre than the British, then one play must be mentioned which, in part at least, owes much to the German stage. This is Sean O'Casey's *The Silver Tassie*, which was rejected by W. B. Yeats and only put on in the Abbey Theatre in 1935, whereas London saw it in 1929. O'Casey was familiar with the work of Strindberg, Kaiser, Toller and O'Neill, and in the

symbolic stagecraft of these dramatists he found a means of projecting, in the second act of his play, the fearful tragedy of battle. The soldiers are almost types from a morality play; a huge howitzer gun dominates the set (very much as the gun does in Goering's *Seeschlacht*), and the use of antiphonal chanting and staccato phrases are further anti-naturalist techniques. A ruined monastery wall has one unbroken stained-glass window of the Virgin: a shattered crucifix with a loosened arm seems to stretch towards her. The flashing light of the guns, the booming organ celebrating mass and the murmuring soldiers accompany the chanting of The Croucher, a deranged figure who chants his distorted version of the passage from Ezekiel on the dry bones. The face of this crazed, demented figure is to be made up as a skull, his hands must be skeletal; he sits somewhere above the group of soldiers and intones his liturgy of death. O'Casey nowhere else indulges in such expressionist devices, but here he seemed to need them, for they conveyed as nothing else could the monstrous nightmare of war.

Other European countries showed the German influence in the theatre: Čapek's *R.U.R.*, reminiscent of Kaiser's *Gas*, has already been mentioned. In the Soviet Union there was initially an acceptance of expressionist practice: Kandinsky and Chagall held official posts, and Meyerhold's productions of Toller proved most successful. But the subjectivity, mysticism and often almost religious concern for the soul of man struggling to free himself not only from the chains of capitalism but even from life itself were obviously alien to a Marxist ideology, and the increasing regimentation and orthodoxy of Soviet cultural life soon drove expressionism from the scene. A word should finally be said about expressionism in the dance: although Germany was the scene of fascinating experiments here the impetus came from Isadora Duncan, who had formulated a new expressiveness in dance, freed from the strictures of classical ballet, and from Mary Wigman, a student of Jacques-

Dalcroze and later collaborator with Rudolf von Laban, who created the dance of absolute abstraction, founded on expressiveness of gesture. The massed choral miming devised by Hanns Niedecken-Gebhard may also have had its origins in Isadora Duncan: his staging of Handel's *Herakles* in Münster (1927), with massed chorus and dance, demonstrated once more the *drama*, the *movement* and the externalization of inner states of soul which lie at the heart of the expressionist mentality.

But the disenchantment adumbrated in Chapter 4 must now be assessed: that particular quality to which the name expressionistic is given emerged in many of the arts of Europe during the twenties but at a time when, paradoxically, its German manifestation was fading. It is probably also true that it carried the seeds of its own demise within itself.

6
Decline?

As early as 1921 the young Alsatian Iwan Goll (who was, incidentally, one of the first to call himself an Expressionist) wrote an article entitled *Expressionismus stirbt* (*Expressionism is dying*); in the following year Brecht's *Trommeln in der Nacht* was performed in Munich. His *Baal*, as was mentioned in section 4, brilliantly parodies and outdoes Johst's play on Grabbe: a new force to be reckoned with now appeared in German theatre. Writing much later in his life, Brecht describes how the 'Oh Man!' plays of his time had appalled him: his youthful aggressiveness, nonchalance and cynicism, and in fact much of his later theatrical method, its spareness, coolness and intellectualism is a deliberate rejection of inflated theatrical expressionism. In Fritz Lang's film *Dr. Mabuse der Spieler* expressionism is rejected as 'a jest, what else?' and in 1925 G. F. Hartlaub organized an exhibition in Mannheim which he termed 'Neue Sachlichkeit' (a term difficult to translate, but meaning, essentially, new realism or matter of factness): a more sober, even disillusioned, attitude was emerging.

Certainly the rhetoric and bombast of German Expressionism faded. But expressionism is a complex phenomenon, and it is true to say that the three main tendencies that superseded it, dadaism, 'Neue Sachlichkeit' and surrealism were all unthinkable without it. The Dadaists' nihilistic antics, their anti-art and deliberate shock-tactics are not far removed from the expressionist urge to form-lessness and extreme situations: Hugo Ball, Emmy Hennings and Hans Arp had been closely connected with German Expressionism before the move to Zurich. 'Neue Sachlichkeit' seems very remote from expressionistic hyperbole, but the deliberate modernity and

big-city terminology is to be found in Benn and, of course,
Marinetti. Willett rightly claims that much early expressionist
verse (i.e. that of Lichtenstein and van Hoddis) was far closer to
the poetry of the later twenties than to the more symbolic and
declamatory writing of the movement's climax. Certain aspects of
expressionism were identified with what could be called the
modernist spirit, if the term is applied to English literature (for
example, Pound's 'Imagism') and an important study of German
Expressionism claimed that 'In many respects the Modern Move-
ment in England and America corresponds not only to Expression-
ism but also to the succeeding German movement, the New
Realism ('Neue Sachlichkeit') with its sceptical and disillusioned
outlook' (see R. Samuel and R. Hinton Thomas, *Expressionism in
German Life, Literature and the Theatre 1910–1924*, Cambridge,
1939, p. 17). And, thirdly, surrealism overlapped to a considerable
extent with expressionism, in the emphasis on, in fact, *expressing*,
on liberation from restrictions, and on the importance of vision: it
was Guillaume Apollinaire (together with Iwan Goll) who
invented the term, as well as being closely connected with the
literary expressionism of the *Sturm* circle.

It is, then, false to assume that expressionism came to an abrupt
end. The Nazis, as has been shown, shared much in common with
it. Goebbels's novel stressed the need to 'shape the outside world
from within' (Willett, p. 202); the experiments with the 'Thing-
spiel' were very close to certain manifestations of German
Expressionist drama, as was the vast, theatrical staging of the
rallies. In Italy, Marinetti's Fascism demonstrated the links be-
tween futurism and Mussolini's ambitions, and the perverted
vitalism of both Fascism and Nazism seem to spring from ten-
dencies latent within the movement. Neither the burning of the
books nor the Degenerate Art exhibition in Munich can quite
conceal the parallels.

In England it was questionable, in spite of Ashley Dukes's

valiant efforts, whether theatrical expressionism struck deep roots: already in 1930 James Agate published his *Their Hour upon the Stage. The Case against Expressionism*, and later in *Red Letter Nights* he attacked *Von morgens bis mitternachts* thus: 'I tried with might and main to see the spiritual significance of Mr. Kaiser's bombinations, but all I could see, or rather, hear, was a small cashier talking at enormous length through a very large hat' (*Affinities*, p. 105). Whether or not the Auden/Isherwood *Ascent of F6* might in any ways reflect German Expressionist concerns is debatable: J. B. Priestley's *Johnson over Jordan* seems a very dim reflection of Kaiser. Yet J. M. Ritchie points out that, when Peter Godfrey, in 1944, opened a Gate Theatre in Hollywood, he chose as one of the plays for the opening the indomitable *Von morgens bis mitternachts*, a play which uncannily refuses to pass into obscurity. As far as the English novel is concerned, the obvious debt to the German Expressionist scene is D. H. Lawrence's *Women in Love*, at which he was working during the First World War. The self-expression of Gudrun before the cattle, her Jacques-Dalcroze eurythmics remind one of Laban's expressionistic dance; Wagnerian and Nietzschean elements are much in evidence in the concept of *Blutbrüderschaft* and in Gerald's ascent to a frozen death in the mountains (this scene, in fact, would be very much in keeping in a Hesse novel or an early Leni Riefenstahl film). Lawrence's dithyrambic rhythms in his poetry, his free, essential verse that cuts to the very centre of things, with its obvious debt to Whitman, also bears comparison with Stadler. His openness to the German situation, his awareness of and sensitivity to the atmosphere there in the early twenties makes it not unlikely that German Expressionism was known to him; he could feel in 1924, 'a sense of danger, a queer, bristling feel of uncanny danger', and could describe 'the destructive vortex of Tartary' (Gray, p. 341).

But the nineteen-thirties brought other ways of feeling, other concerns and modes of expression: the 'Pylon' poets, the Spanish

Civil war, the Marxist orientation. The premises seem so different, but expressionism also shared a concern for social issues, and although Stephen Spender, in his review of the Samuel/Thomas study of German Expressionsim which appeared in *The London Mercury* in March 1938, repudiated the suggestion that there may have been expressionist elements in his work, nevertheless his description, in *Poetry since 1939*, of the poetry of the thirties, seems most applicable to expressionism – the emphasis on modernism, on powerful images, on the sense of communal disease and a left-wing inclination. But closer to the more dynamic aspects of expressionism was the so-called 'New Apocalypse' poetry of the early forties, the reaction against the notion of poetry as merely social reporting in favour of an emphasis on individualism and inner vision. The names that spring to mind here are, of course, Dylan Thomas, together with George Barker and David Gascoyne; the rejection of Auden's self-conscious, over-intellectualized manner, the intoxication with words and a love of myth seem very much in the expressionist mode. It is Dylan Thomas particularly who comes closest to the dynamism of much expressionist poetry, with his plethora of self-generating images; he had certainly read, in Vernon Watkins's translations, Novalis, Hölderlin and Rilke, but probably little else of modern German poetry.

AFTER 1945

It is tempting to compare the German situation in 1945 with that in 1918 to see whether or not a form of writing emerged similar to that of post-1918 German Expressionism. But the collapse of 1945 totally paralyzed all cultural life: this was a veritable zero-point as 1918 had never been. The massive physical destruction, the dawning awareness of the full horror of Nazism, and the division of Germany created a completely different set of conditions from those obtaining in the early twenties. But it is interesting that at

least one playwright attempted, in 1947, to portray the nihilism, helplessness and despair of those years in an almost German Expressionist way: this was Wolfgang Borchert, whose play *Draußen vor der Tür* (*The Man Outside*) might almost have been written by Ernst Toller. The stylized characters – the Girl, the Man, an Undertaker (Death), an Old Man (God), also the River Elbe – the short scenes and above all the element of the grotesque, would not have been out of keeping twenty-five years earlier. But Borchert was soon forgotten: the *enfant terrible* of the twenties, Bert Brecht, returned to the Schiffbauerdamm Theatre to dominate, paradoxically, the West German Stage.

What, then, remains? The modernist techniques associated with early expressionism have become part of the stock-in-trade of modern writing, although it would seem that the frenzied pathos and the hyperbole are gone forever. Yet expressionism is, ultimately, an attitude of mind which can emerge at any time, a particular kind of response to a given number of factors. Self-expression, religious fervour, the predilection for the irrational and the occult, also political activism and total disregard for authority are, as Willett quite correctly points out (p. 244), very much part of the cultural scene today, and although the word 'expressionism' is now rarely used (yet did not the fifties talk of 'Abstract Expressionism' in painting?), the frame of mind and emotional state the term signifies are timeless conditions. If the term, one of Herbert Read's 'necessary' words like idealism and realism, designates the right to dream (to have nightmares even), the right to instinctive freedom and to revolt against automatism and stultifying restrictions – above all the right to express and create – then it is a positive attitude to life, for these are precious privileges; the tendency towards the extreme, with its own dangerous fascination, is a necessary concomitant.

Bibliography

I. GENERAL ACCOUNTS

ARNOLD, A., *Die Literatur des Expressionismus*, Stuttgart, 1966.
A very useful account of the movement's origins.

EDSCHMID, K., *Frühe Manifeste*, Hamburg, 1957.

FRIEDMANN, H. and MANN, O. (editors), *Expressionismus. Gestalten einer literarischen Bewegung*, Heidelberg, 1956.
A collection of essays of unequal merit.

KRISPYN, E., *Style and Society in German Literary Expressionism*, University of Florida, 1964.

MARTINI, F., *Was war Expressionismus?* Urach, 1948.

MYERS, B. S., *The German Expressionists*, New York, 1957.

PÖRTNER, P., *Literatur-Revolution 1910–1925*, Darmstadt, 1961.
Two volumes of documents, manifestoes and programmes.

RAABE, P. (editor), *Expressionismus. Literatur und Kunst 1910–1923*, Munich, 1960.
A most informative catalogue of the Schiller Nationalmuseum Exhibition.

RAABE, P. (editor), *Die Zeitschriften und Sammlungen des literarischen Expressionismus*, Stuttgart, 1964.
An indispensable bibliography.

RAABE, P. (editor), *Expressionismus. Aufzeichnungen und Erinnerungen der Zeitgenossen*, Olten, 1964.

RAABE, P. (editor), *Expressionismus. Der Kampf um eine literarische Bewegung*, Munich, 1965.
A very useful selection in paperback (Deutscher Taschenbuch Verlag) of writings and manifestoes by several German Expressionists.

ROTHE, W. (editor), *Expressionismus als Literatur*, Berne, 1969.
A good selection of essays on various writers, plus bibliographies and biographical notes.

MUSCHG, W., *Von Trakl zu Brecht*, Munich, 1961.

SAMUEL, R. and HINTON THOMAS, R., *Expressionism in German Life, Literature and the Theatre 1910–1924*, Cambridge, 1939.
The first serious account of the movement in English, and still a most useful study.

SOERGEL, A. and HOHOFF, C., *Dichtung und Dichter der Zeit.* Vom Naturalismus bis zur Gegenwart. 2 vols., Düsseldorf, 1961 and 1963.
A general, but perceptive, study of the period.

SOKEL, WALTER, *The Writer in Extremis*. Expressionism in Twentieth Century German Literature. Stanford, 1959.
An indispensable study of expressionism and 'modernism'.

WILLETT, J., *Expressionism*, Weidenfeld and Nicolson, 1970.
The fullest account in English of the movement in all its various manifestations.

2. STUDIES OF SPECIFIC GENRES

L'Expressionnisme dans le théâtre européen. (Edition du centre national de la recherche scientifique), Paris, 1971.
Various papers from a colloquium held in Strasbourg in 1968.

BAULAND, P., *The Hooded Eagle.* Modern German Drama on the New York Stage. Syracuse, 1968.
Contains a useful account of the impact made by German Expressionist drama in America.

DIEBOLD, B., *Anarchie im Drama*, Frankfurt/M., 1921.
An excellent early description of German Expressionist drama.

DENKLER, H., *Drama des Expressionismus*, Munich, 1967.

EISNER, LOTTE, *The Haunted Screen*, London, 1969.
A study of German Expressionist cinema.

GARTEN, H. F., *Modern German Drama*, London, 1959.

HAMBURGER, M. and MIDDLETON, C. (eds.), *Modern German Poetry 1910–1960*, London, 1963.

HILL, C. and LEY, R., *The Drama of German Expressionism*. A German-English Bibliography, University of North Carolina Press, 1960.

KRACAUER, S., *From Caligari to Hitler*, Princeton and London, 1947.
A fascinating account of expressionist cinema and the social background.

PINTHUS, K., *Menschheitsdämmerung*, Hamburg, 1957.
A reprint of the most representative anthology of German Expressionist poetry.

RÜHLE, G. *Theater für die Republik 1917–1933*, Frankfurt/M., 1967.
A judicious selection of excerpts from contemporary criticism of the German theatre at that time.

SCHNEIDER, K. L., *Zerbrochene Formen*. Wort und Bild im Expressionismus. Hamburg, 1967.

WALDEN, N. and SCHREYER, L. (editors), *Der Sturm*. Ein Erinnerungsbuch an Herwarth Walden und die Künstler aus dem Sturmkreis. Baden-Baden, 1954.
Reminiscences of the Berlin *Sturm* circle around Herwarth Walden.

3. STUDIES OF PARTICULAR WRITERS

CLARK, B. H., *Eugene O'Neill*. The Man and his Plays. New York, 1947.
Contains an account of O'Neill's attitude to German Expressionist drama.

DAHLSTRÖM, C. W. L., *Strindberg's Dramatic Expressionism*, Ann Arbor, 1930.

EYKMAN, C., *Die Funktion des Häßlichen in der Lyrik Georg Heyms, Georg Trakls und Gottfried Benns*, 1965.

HOFFMANN, E., *Kokoschka. Life and Work*, London, no date.

KENWORTHY, B. J., *Georg Kaiser*, Oxford, 1957.

The fullest study in English of this prolific playwright.

KRAUSE, D., *Sean O'Casey. The Man and his Work*, London, 1960.

Contains a discussion of expressionistic elements in O'Casey.

HELLER, P., 'The Masochistic Rebel in Recent German Literature' in *Journal of Aesthetics and Art Criticism*, 11, 1952/53.

Contains a discussion of Ernst Toller.

HINTON THOMAS, R., 'Notes on some unpublished papers of Reinhard Sorge' in *The Modern Language Review*, 1937.

PAULSEN, W., *Georg Kaiser*, 1960.

PINTHUS, K., 'Walter Hasenclever. Leben und Werk'. An introduction to Hasenclever's *Gedichte, Dramen, Prosa*, 1963.

PIPER, R., *Vormittag. Erinnerungen eines Verlegers*, Munich, 1947.

An account by the publisher of the reception of Dostoevsky in Germany during the time of Expressionism.

RÖLLEKE, H., *Die Stadt bei Stadler, Heym und Trakl*, Berlin, 1966.

SCHNEIDER, K. L., *Der bildhafte Ausdruck in den Dichtungen Georg Heyms, Georg Trakls und Ernst Stadlers*, Heidelberg, 1954.

An excellent analysis of the use of imagery and metaphor in the work of these three poets.

VALGEMAE, M., 'O'Neill and German Expressionism' in *Modern Drama*, 10, 2, September 1967.

Volumes 2 and 3 of the 'German Men of Letters' series (Oswald Wolff, London) contain essays of varying quality on the main figures of German Expressionism. The essay on the movement by Hector Maclean in *Periods in German Literature* (ed. J. M. Ritchie) is a perspicacious one. Professor Ritchie also edits a series of translations of German Expressionist plays for Calder and Boyars: *Seven Expressionist Plays* (including Kokoschka's *Murderer Hope of Womankind*); *Vision and Aftermath* (consisting of four war

plays and including Goering's *Naval Encounter*); *Five Plays* of Georg Kaiser (that is, *From Morning to Midnight, The Burghers of Calais* and the *Gas* trilogy) and lastly *Scenes from the Heroic Life of the Middle Classes* by Carl Sternheim. Professor Ritchie has recently written a useful monograph on *Gottfried Benn* (Oswald Wolff, 1972), which contains a translation of *Ithaca* and the *Confession of Faith in Expressionism.*

phy and Budgeting Decisions", *Annual Economic Review*, 1960, 6–19.

CRAINE, R. and BOWMAN, E. H., *Management Decision Making*, Irwin and the Free Library, 1971, and *Indications from the World*, 1971.

HOFMANN, H. L., "An empirical Professor Problem", *International Journal of Management Science*, vol. 14, 1967.

WORLD, B., "Theories of the Firm", *Readings on the Theory of the Firm*, D. B. Needham, ed., 1970.

Index